NOTORIOUS KANSAS BANK HEISTS

NOTORIOUS KANSAS BANK HEISTS

GUNSLINGERS TO GANGSTERS

ROD BEEMER

Published by The History Press
Charleston, SC
www.historypress.net

Copyright © 2015 by Rod Beemer
All rights reserved

Back cover, top right: This fully restored Ely-Norris cannonball safe was as burglar proof as any safe of its era. *Courtesy Anthony Martin.*

First published 2015

Manufactured in the United States

ISBN 978.1.62619.835.7

Library of Congress Control Number: 2015951454

Notice: The information in this book is true and complete to the best of our knowledge. It is offered without guarantee on the part of the author or The History Press. The author and The History Press disclaim all liability in connection with the use of this book.

All rights reserved. No part of this book may be reproduced or transmitted in any form whatsoever without prior written permission from the publisher except in the case of brief quotations embodied in critical articles and reviews.

Why did I rob banks? Because I enjoyed it. I loved it.
—*Willie Sutton, attributed*

Contents

Acknowledgements	9
Introduction	11
1. Examples of the Contest	15
2. The Strange and the Bizarre	21
3. Wrong Career Choices	35
4. Amateur Yeggs and Unsolved Robberies	49
5. The Deadliest Heists	65
6. Fighting Back: Citizens, Bankers and Vigilantes	91
7. The Professionals: The Business of Robbing Banks	107
8. The Professionals: The Kansas Bureau of Investigation	123
Notes	131
Bibliography	137
Index	139
About the Author	143

ACKNOWLEDGEMENTS

Books are not do-it-yourself projects but require the help of many individuals and institutions. Therefore, a sincere thank-you is offered to the following: Sonya Reed, director, and Vicki Krehbiel, assistant director, of the Lane County Historical Society in Dighton, Kansas; and Laurie Oshel, assistant director at the Finney County Museum and Finney County Historical Society in Garden City, Kansas. Also thanks to the helpful staff at the Kansas State Historical Society Research Room—Jessica Ditmore, Teresa Coble, Nancy Sherbert and Lisa Keys—as well as Shawn Marie Stover, director, Cowley County Historical Society Museum.

Jim Maag, former president of the KBA (Kansas Bankers' Association), saved me countless hours of research by sharing the index he'd compiled for more than 1,200 issues of the *Kansas Banker* magazine. Lynne Mills and Julie Taylor at the KBA office in Topeka were also very helpful and professional.

Librarians are essential to any research endeavor, so a special thanks to Amanda Stephenson at the Hutchinson Public Library Reference Department; Toni Bressler at the Morton County Public Library; Charlene Blakeley, director, Kiowa County Public Library; and John Brubaker and Leslie Hargis at the Minneapolis Public Library.

Individuals, too, are a rich source of help and inspiration: Garden City businessman Mick Hunter introduced me to several community leaders who provided leads to stories of the Fleagle family. Margaret Symns graciously shared stories of her father, Logan H. Sanford, who was the sheriff of Stafford County before becoming the second director of the Kansas

Acknowledgements

Bureau of Investigation. John W. Nixon, director of the Stockade Museum in Medicine Lodge, provided valuable and helpful information. And good friend Debra Goodrich has encouraged me to tell these stories from the first time we discussed the idea.

Most importantly, a special thanks to my wife, Dawn, who is patient and supportive of my addiction to books, and my son Chuck, who works magic with images and illustrations as well as fixing computer problems I manage to create.

If I've failed to mention someone, it's not because I'm not grateful but because I'm sometimes forgetful.

Introduction

Banks and bankers were not always popular and, perhaps for some, still aren't. Our forefathers shared some of these same feelings. The First Bank of the United States opened in 1791, but the public had an innate distrust of banks and the bank's charter wasn't renewed in 1811. For the next fifty years, banks on the expanding frontier came and went as the economy boomed and busted. "Western banks sprang up almost exclusively as a response to an insufficient money supply. The problem was currency not credit."[1] This lack of a sanctioned and stable exchange medium led to many stop-gap methods to keep the wheels of commerce grinding.

Part of the reason for this drought of currency was because people had a real, and understandable, fear that once banks became established in a community or state or country these money changers would soon control everything.

Alexander Hamilton was one of the founding fathers who saw the need for a central bank, but this idea wasn't popular with many of his peers. "The bank was strongly opposed by Thomas Jefferson, who questioned its constitutionality, and James Madison, who viewed bankers as 'swindlers and thieves.' Many in the South openly despised banks, seeing them as tools for the wealthy to take advantage of the rest of the population."[2]

Bank distrust, and often hate, was real. As an example, Nebraska became a territory in 1854, and "notwithstanding this emerging need, at that time banking still was a crime and thus punishable under the laws of

Introduction

the territory, as laid down in the criminal code passed by the legislature at its first session in 1855."[3]

The first three territorial governors of Kansas were strongly anti-banking, and banking also reached criminal status in Kansas during its territorial period. "Robert J. Walker commented that he 'would not sanction the establishment of any bank of issue in the territory,' while James Deaver thought Congress did not give the states the power to charter banks, and Samuel Medary described banks as 'demoralizing and seductive.'"[4] These anti-banking views led to all unchartered banks being declared illegal in 1857. "There were no banks of issue in Kansas up to 1864, unless possibly, the Lawrence Bank, which had a territorial charter, and issued bills which circulated and were honored. The bills were printed in red ink."[5]

Perhaps the citizens' unpopular view of bankers was due to some of their practices during the early territorial days of the state:

> *In Lawrence, in 1857, Samuel N. Wood had a bank office in one corner of a small grocery store on Massachusetts street. There were piles of flour and bacon in the little building, Wood's corner occupying about eight feet square, with a bay window in front, in which he displayed land-warrants, gold and bank-notes in a tempting manner. One day a debtor of this banker passed by in the middle of the street, being somewhat intoxicated. Mr. Wood rushed out and seized him, throwing him down and taking his pocketbook. After helping himself to the amount due him he returned the pocketbook to its place and allowed him to proceed. This was a novel, but an economical and expeditious way of making a collection—quite a contrast to the delays which creditors sometimes experience in the courts nowadays.*[6]

Banks were especially unpopular in the farm belt of the trans-Mississippi plains states during the Depression and dust bowl, when banks foreclosed on thousands of farmers and businesses.

Many of the poor people struggling to survive just didn't consider robbing banks a very serious crime.

> *In the first years of the depression, a typical attitude toward bank robbing was exemplified by the mother of a minor crook named George Magness. He and three friends robbed the only bank in the tiny town of Edna. Two days later they were captured near Stinnet, Texas, returned*

Introduction

Kansas map with all counties identified. *Courtesy of Chuck Beemer.*

> *to their home county for trial…When his mother saw her son behind bars, she became incensed and sought out Sheriff Al Coad. Looking the law officer right in the eye, the irate mother began to berate him for incarcerating her son.*
>
> *"Hell, sheriff," she concluded, "bank robbin' aint [sic] hardly no crime at all."*[7]

Despite the mother's feelings, robbing banks was a crime, and as with all crime, from the very beginning it has always been a contest between the good guys to develop methods of catching the bad guys who were just as earnestly seeking ways to avoid being caught.

There is probably more misinformation about bank robbers and their crimes than there is documented truth—and, in most cases, more questions than answers. This work has attempted to glean the most probable facts about each case while knowing full well that errors are inevitable, but they are not intentional.

The focus of this work is to examine the infamous and the forgotten criminals who preyed on Kansas banks from 1861 to 1941 contrasted against some of the measures the banks took to defend and protect themselves coupled with law enforcement's struggle to stem the tide of robberies.

Technically it can be argued that there is a distinction between robberies and burglaries, but for this work the term robbery will be used for either

Introduction

a daylight robbery or a nighttime burglary. As our language changes, the distinction becomes less rigid, but they both refer to someone taking something that doesn't belong to them or stealing something. In this work the term bank robbery, or robberies, will mean someone stealing money from a banking institution regardless of the method used.

1
Examples of the Contest

Atchison, Kansas chief of police Willard C. Linville responded to a bank robbery in process no doubt realizing there could be danger involved, but he may not have expected to be running directly into the withering fire of a Thompson submachine gun. But that's exactly what happened as reported by the *Kansas City Times* on March 13, 1959.

Atchison Recalls Day of Violence

Atchison, Kas., March 12.—Today, 25 years ago, was one of the most exciting days in the history of this city, located 50 miles north of Kansas City on the Missouri river.

At 8:30 o'clock in the morning on Monday, March 12, 1934, four armed robbers smashed their way through a plate glass side door of the Exchange National bank. Inside the bank the employees were gathering for work and most of them had arrived.

One With Machine Gun.
Three of the bandits were masked and carried pistols. The fourth wore no covering over his face and held a machine gun. All wore slouch hats with the brims pulled down. The collars of their jackets were turned up. All appeared to be men about 30 years of age.

Outside the bank stood two get-away cars in which the robbers had arrived. They ordered bank employees to carry $21,000 of counter cash, consisting of currency and coin, out to the cars.

One of [the] bandits ordered two officials of the bank, the late Ed Iverson and the late George Wolf, to open cash vaults inside the large bank vault. When told that the cash vaults would not open until 9 o'clock because of the time locks the bandits became incensed. One beat Iverson over the head with his gun and the latter was critically injured. Wolf was struck on the back of the head by another bandit.

At one time during the robbery one of the bandits addressed a companion "Dillinger." Later the police said this was done to impress the bank employees.

Police Chief on Way.
The bandits were in the bank a little more than five minutes when one shouted: "Here he comes. Let's go!" The bandit referred to Chief of Police Willard C. Linville. When the bandits entered the bank the janitor, Sam Overstreet, was washing the bank's front windows. He slipped next door to a shoe repair shop and called the police station. Linville was the only officer in the station. He strapped on his gun and ran towards the bank, two blocks from the station.

Linville was still a half block away from the bank when the machine gunner opened up on him.

The machine gun referred to here is undoubtedly the Thompson submachine gun, which was designed by John T. Thompson and first mass produced by the Colt Manufacturing Company in 1921. The company was contracted to produce "the first run of 15,000 Thompson Submachine Guns." But "Colt refused additional orders for the Thompson because it had quickly gained infamy as the 'weapon of choice' for notorious gangsters of the time. This cost the company many millions of dollars, as more than 1,750,000 'Tommy guns' were manufactured during World War II."[8]

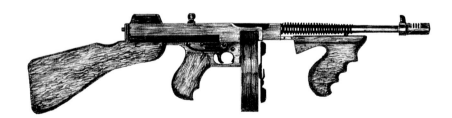

The Thompson submachine gun, commonly referred to as a "Tommy Gun," became a favored weapon for gangsters during the 1920s and 1930s. *Illustration by Chuck Beemer.*

The Thompson was chambered for the .45 ACP cartridge and, depending on the model, was capable of firing from 600 to 1,500 rounds per minute. Due to this rapid rate of fire, it was soon referred to as the "Chopper," "Chicago Typewriter," "Trench Broom" and appropriately, in this instance, the "Street Sweeper."

> *The chief was struck by six bullets and 11 bullets went through his flapping topcoat. He did not fall until he reached a drug store across the street from the bank. There he staggered into the front door and the arms of a friend. His gun belt was shot off at the door of the drug store.*
>
> *The bandits escaped, taking nine of the bank employees as hostages...*
>
> *Hostages Cling to Car.*
> *Some of the hostages were forced to ride on the running boards of the cars. One of these, Ed Iverson, weak from the brutal beating he received inside the bank, fell off the car he was riding as it rounded a curve at Twentieth and Main. A quarter of a mile farther on the women were released at Omaha junction. The remaining hostages were released four and one-half miles southwest of Atchison on U.S. 59.*
>
> *The bandits were never captured...*
>
> *W.C. Linville made a rapid recovery from his bullet wounds. Today, at the age of 80, he enjoys fairly good health and still has two of the bullets in his body. One is in the right arm and the other, which pierced his upper left chest, is lodged near the spine. He was shot in both legs, both arms, his upper chest and his left hand. The only ill effect he has suffered is an occasional twinge of pain in his wounded hand.*

Police Chief Linville, like most other law enforcement officers, was ready and willing to put his life on the line, but often, these officers were facing overwhelming firearms superiority in the hands of the criminals.

The word "black" when used as an adjective almost always denotes a bad event, such as black magic, black eye, black widow, black cat or Black Death. When it is used in combination with financial institutions it also usually lands on the disastrous side of events, like Black Monday, Black Tuesday and Black Friday.

October 19, 1987, marked the largest one-day drop in the stock market and was dubbed Black Monday; on Black Tuesday, October 29, 1929, the markets fell drastically, which ushered in the Great Depression, and September 24, 1869, was deemed Black Friday after gold speculators attempted to corner the gold market. The attempt was unsuccessful: the gold market collapsed, and the stock market crashed.

Another lesser-known event occurred on Friday, July 14, 1933, and could also qualify as Black Friday for two men associated with the Labette County State Bank in the town of Altamont. Alvie Payton and Kenneth Conn's association with this financial institution was robbery, or rather an attempted robbery, and the results were just as black. Payton and Conn were among eleven prisoners who had escaped from the Lansing State Penitentiary on Memorial Day, May 30.

During the Roaring Twenties and the Dirty Thirties, bank robberies occurred all too often in the small towns of Nebraska, Kansas and Oklahoma. By mid-1933, Kansas had experienced more than one hundred such robberies. Consequently, the small rural banks began to take it on themselves to protect their investments and their deposits.

The Labette County State Bank in southeast Kansas was one such bank. Isaac (Ike) McCarty was the cashier, and his wife, Colene, was assistant cashier. Ike's father, A.H. McCarty, was the bank vice-president. On this Friday morning, the family members were busy in the bank getting ready for the day's business. Ike noticed a new Ford coupe drive by with Oklahoma license plates. When the car turned and pulled up in front of the bank, Ike told his wife, "I'm going upstairs."

His wife, Colene, knew what this probably meant, for "upstairs" referred to a room above the bank vault with a small window overlooking the bank interior. A rifle, a shotgun and plenty of ammunition were waiting nearby if needed.

A few minutes before opening time, two men got out of the car and walked to the bank door, which was locked. One tapped on the door until Colene walked over and opened it. "I know we're a little early," one of the men said, "but we'd like to make a deposit."

"That's okay," Colene answered, returning to her teller cage and handing one of the men a deposit slip. As she did so she noticed the other man pulling out a gun; unseen, she quickly activated the silent alarm and then raised her hands.

"Put 'em up," the gunman said as he pointed the gun at her.

"I've already got 'em up," she calmly replied. "I saw your gun."

The other robber went to the conference room at the back of the bank where the vice-president, bank president and a mail carrier were visiting.

"This is a stick-up," he said, waving his gun at them.

At first the men didn't take him seriously.

"Stick 'em up or I'll kill you!" the man shouted.

That got their attention, and they quickly complied with the demand before being marched out and told to sit down behind the teller cage. The other man began cleaning out the cash drawers.

Upstairs, Ike waited for the bandits to take the hostages to the vault, which was usually what happened during a holdup. While the three hostages sat behind the counter, Colene was allowed to stand. The alarm had galvanized the town, and looking outside, Colene saw armed citizens running toward the bank. Suddenly, four shots rang out. The outlaws looked up and saw that all four of their car's tires had been shot out.

One of the robbers grabbed Colene and told her she was going with them.

"I'm ready," she replied.

The other robber was leading the way out when Ike touched off a round with the shotgun. The charge caught the man in the face and put him down. The man's partner thought the shots were coming from outside the bank so he grabbed Colene and told the elder McCarty to have the men outside stop shooting or he'd kill the woman.

"I'll have to go outside to do that," the banker replied.

"Well, go out and tell them to stop and then come back in," yelled the bandit.

As Ike's father walked toward the door, his son exchanged the shotgun for the rifle and put a round in the bandit behind the teller's cage.

"Don't shoot," Colene yelled, "I'm still back here."

Another rifle shot and the wounded man rolled over and lay still.

Citizens gathered at the bank door. "Is it OK to come in?"

Ike came down from upstairs. "Yeah, I got 'em both," he said.

Alvie Payton, the bandit Ike shot with the shotgun, was still alive and pleaded to be taken to a hospital. "I've got $1,500," he said. The other robber, Kenneth Conn, was dead; Ike's second shot had struck him just below the heart.

Payton was taken to the Oswego County Hospital at Lansing, where he was treated. He lived and was paroled in 1941 but was later picked up on a federal bootlegging charge and sent to Leavenworth. He received a pardon on Saturday, June 29, 1957, but every day was a black day for Payton because he was permanently blinded in both eyes by the shotgun blast.[9]

Bankers were taking robbery very seriously, and the robbers didn't always escape with the loot or their lives.

2
THE STRANGE AND THE BIZARRE

Shortly after opening for business on the morning of September 23, [1938] the First National Bank of Parsons experienced an attempted but unsuccessful robbery attack by an abominable bum with a bomb… jeopardized not only his own but the lives of many persons by the threatened use of bombs and several sticks of dynamite."[10] Much to the robber's regret, this bank was equipped with another anti-theft device used by banks to counter, and conquer, the inventive bank robber.

"Beginning in the 1920s, certain safes and vaults included (or were fitted with) theft-deterrent devices containing chemical vials."[11] Diebold Bahmann Safe Company was founded in 1859 in Cincinnati, Ohio. The Great Chicago Fire in 1871 destroyed almost everything within about four square miles of the city. There was 1 exception—actually 878 exceptions, as that was the number of Diebold safes that remained intact with undamaged contents. In 1876, the company changed its name to the Diebold Safe & Lock Company and continued manufacturing reliable safes plus diversifying into other products.

John Dillinger's famous bank robbery and murder spree in the 1930s prompted Diebold's creation of a robbery-deterrent system for banks that flooded the bank building with tear gas that caused bandits to abandon the robbery and flee outside to fresh air.[12]

Badger Safe Protector was another company that manufactured tear gas devices, and its last patent was issued in 1981. Although production of the tear gas devices seems to have ended by the late 1980s, this type of anti-robbery device is still being found on old safes today.[13]

An illustration showing the tear gas delivery heads above the cashier window. *Illustration by Chuck Beemer.*

These devices could be set off by a bank employee or activated automatically if the safe was tampered with. The downside of these devices is that after the gas is released it can cause irritation to the eyes, skin and respiratory system, plus nausea and vomiting. Once the gas is released, the building often needs to be evacuated and checked by authorities before being reentered by owners, employees and the public. Release of a large amount of gas could require the building, and in some cases the adjoining buildings, to be unsafe for up to several days.

"On December 4, 2003, a hazardous materials (HazMat) release occurred at a jewelry store in Beloit, Wisconsin, when the store owner tightened a screw on the door of an old safe outfitted with a chemical thief-deterrent device."[14]

The resolution of the bum-with-a-bomb robbery ended quickly due to the theft-deterrent device installed in the Parsons bank. "Members of the bank force quickly released the gas installation. Under standing arrangement with

the Parsons police department, patrolmen were on duty near the several banks. Officer Pat Dixon quickly met the situation by covering the bandit as he was forced out of the banking rooms by the gas and when the bandit threatened him Dixon shot twice and this particular criminal is no more."[15]

The criminal career of Elmer McCurdy definitely falls in the bizarre category. Elmer was born in Washington, Maine, in January 1880. When he was fifteen years old, the circumstances of his family began to bend his mind, so he ran away from home in 1895. He then lived with his grandparents for three months, where he learned the plumber's trade. Apparently, he learned the trade very quickly, but it failed to hold his interest.

Elmer left Maine and arrived in the town of Ola, Kansas, in 1903. Plying his trade as a plumber, he moved around southeast Kansas and southwest Missouri for a few years before stopping in Cherryville, Kansas, where he hired on as a miner. In 1907, he enlisted in the military and served a three-year stint after which he located in St. Joseph, Missouri. After his discharge, it's unclear how hard he looked for a respectable job, but he worked hard at drinking, which eventually led to his arrest. This little brush with the law accounted for his friendship with another petty criminal who regaled Elmer with tales of robbing banks and eluding the law in Oklahoma. Soon, Elmer visited his new friend, Walter Jarrett, in Lenapah, Oklahoma. Jarrett had two brothers, Lee and Glen, who were planning to rob the Iron Mountain train. Jarrett, trying to impress his brothers, told them that Elmer was an experienced safe cracker and invited him to join the train robbery gang.

Although Elmer had been introduced to nitroglycerin while in the army, he wasn't an experienced safe cracker but decided to play the role anyway. During the robbery, he first used three charges of dynamite, which failed to open the safe. He then switched to nitroglycerin. Unfortunately, since this was his first effort to crack a safe, he used too much nitro.

> *The fourth explosion, in any case, unhinged the door of the safe and sent it flying through the ravaged car. When the smoke had cleared, the bandits peered inside and beheld the booty, $4,000 in silver coin, almost all of it fused by the heat of the four successive blasts into a glittering mass that stuck to the inside walls of the safe. The bandits were staring at what would amount today to $70,000. Yet no shovel or pick, no amount of banging or grunting or cursing,*

> *could pry it loose, try as they might, and try they did…In their last few minutes, the bandits were reduced to pawing through the pouch* [registered mail] *stooping here and there to pick up scattered coins from the floor, and resorting to petty larceny—McCurdy relieving Pinkney* [train's night mail clerk] *of his gold pocket watch.*[16]

Not one to give up on his new career of safe cracking, Elmer and two other men decided to rob the Chautauqua, Kansas bank. Elmer justified the robbery because the bank had refused him a loan. On the night of September 21, 1911, Elmer and the other two men broke through the wall of the bank and entered the vault. Elmer apparently was a slow learner in the art of nitroglycerin charges, and once again, he was too liberal with the nitro. According to the *Sedan* (Kansas) *Times Star*, "It blew the outer door off the safe and threw it with terrific force against the front door of the vault. That vault door, with its iron frame, was blown out of place and across the room to the plate glass window. It plowed its way through the furniture, leaving everything in its path a complete wreck."

Elmer and friends had retired to the alley before setting off the charge, and when they again entered the bank after the explosion, they found the inner door of the safe still securely closed. Elmer set another charge, but before touching it off his accomplices warned him that the town had been awakened so they grabbed some silver and gold coins that were on the counter and then mounted their horses and spurred out of town with a grand take of $150.

Again, not one to quit, Elmer and a new partner, Amos Hayes, heard about the Osage Indian payments that were transported via the Katy Railroad. They determined the payments would be shipped on October 4, 1911, aboard the MK&T train number 23. The robbery was pulled off about 1:00 a.m. three miles south of Okesa, Oklahoma. The story that ran on October 6 in the *Bartlesville* (Oklahoma) *Enterprise* stated that the

> *haul made by the robbers was one of the smallest in the history of train robbing. They failed to find as much as a copper cent in the safe of the express car. The express agent opened the door for them and allowed them to look in. They took $40 in currency and a Hampton watch worth $25 from the mail clerk, a cravnette coat worth $25 from the conductor McCormick, and from the train auditor, Paul Hagan, they took an automatic revolver. They also made away with two gallons of whiskey, and during the holdup; they knocked the head of*[f] *two kegs of beer and drank part of the contents. After the robbery, the men escaped hastily.*

Why such a meager haul? The not-too-bright outlaws had held up train number 29 instead of train number 23. The one thing they did do in a big way was stir up a posse of over fifty officers, including several federal officers. Elmer, using the alias Frank Amos, was trailed to a ranch belonging to Charley Revard. After sharing the whiskey with some of the ranch hands, he asked for a place to bed down for the night. The hay barn was the place offered. Elmer retired, and shortly thereafter, posse member Dick Wallace and two brothers, Robert and Stringer Fenton, arrived.

The next morning at first light, the gun battle began in earnest, continued for an hour and then ceased. Elmer McCurdy was dead. His body was taken to the Johnson Funeral Home, placed in a wicker basket, photographed and identified as Elmer McCurdy before being turned over to the undertaker, who embalmed the body and, while doing so, added arsenic to the embalming fluids. This was similar to the methods used to preserve Egyptian mummies.

Everyone assumed that Elmer's body would soon be claimed, but after six months' residence in the back room of the mortuary, a curious onlooker found that Elmer's preservation was still perfect. They also discovered that when his body was removed from the slab, Elmer could still stand upright. As the "Embalmed Bandit," he became an object of local interest. Mr. Johnson, the mortician, decided to dress Elmer in the clothing he had worn in his last gunfight and stood him in the corner of the mortuary. To add a touch of realism, someone placed a rifle in Elmer's hand, and there the outlaw stood for five years.

In October 1916, a series of events began to unfold in which Elmer became an attraction at a traveling carnival show, which he stayed with until 1922. He was then sold to the Museum of Crime, where he resided until 1971, when he was sold to the Hollywood Wax Museum. Elmer had arrived in Tinsel Town. However, it was a short engagement at the Hollywood Museum because the show was canceled, and in October of that year, he was sold to Ed Liersch and D.R. Crydale, who opened a wax museum on Long Beach Pike. At this time, Elmer had shriveled up so much it was said that he looked like an eight-year-old child. His casket had fallen apart, so he was displayed in a cardboard box.

The cardboard box was his home for five years until he was hung up in a fun house in Long Beach called the Laff in the Dark. In 1978, the fun house was closed to the public and leased to Universal Television Studios for the filming of an episode of the *Six Million Dollar Man*. Elmer's strange afterlife was coming to a close on the set of this popular TV show.

Chris Haynes and his crew were prop men for Universal Studios whose jobs were to prepare the Laff in the Dark for some of the TV shots that would be filmed inside. Chris and crew

> *had spent the early part of the morning hauling props through what looked like the inside of a very large magician's box…The tracks snaking the interior led, at one point, to a mannequin hanging from a wall with a noose around its neck. The work crew had begun talking about the mannequin immediately, with its strange glow-in-the dark paint job…A few of Chris's crewmates began poking at the hanged man. It seemed as light as balsa wood and stirred in the slight breeze of workers passing by. Someone guessed that it was made of papier-mâché. Chris stopped for a moment, then walked over to it and pulled on its arm, which snapped off…He brought the arm over to one of the guys and pointed at the bone.*
>
> *"Does that look like papier-mâché?" he asked.*
>
> *Just to make sure, the two walked back to the dummy, which was unclothed, and Chris checked between his legs. Sure enough, he was staring at a complete male package, shrunken and mummified, but all there.*[17]

Authorities were notified, and Elmer was later examined by the Los Angeles medical examiner and tagged as John Doe #255. An autopsy revealed that the remains were human and the cause of death was from a bullet wound. It also revealed that arsenic had been used to embalm the body for burial. Arsenic had only been used for embalming between 1905 and 1930; therefore, their John Doe had to have been killed between those two dates.

The coroner's office issued a news release that led to the identification of the body as that of Elmer McCurdy.

Once again, authorities waited for someone to claim the body, but it seems that Elmer wasn't very dear to anyone's heart, so the body remained in California until a group of western historians in Oklahoma decided to bring Elmer's remains back to Oklahoma.

> *On Saturday, April 16, 1977 Elmer left Los Angeles for Oklahoma's Territorial Capitol, Guthrie. The Gill-Lessert Funeral Home in Ponca City provided an appropriate hearse—horse-drawn, glass sided, draped inside with rich velvet curtains. Truman Moody provided a coffin he had made out of white pine. The lid was embossed with a plain wooden cross… Even though Elmer wasn't a famous outlaw from Oklahoma, his site for*

> burial was chosen in Guthrie's Summit View Cemetery Boot Hill section… The morning of the burial, a funeral home in Oklahoma City brought Elmer to…Guthrie. At 10:00 a.m., the burial procession assembled on Pine Street, about a quarter of a mile north of the cemetery entrance. The Funeral home brought Elmer's coffin out in an automobile and transferred it there to the black, horse-drawn hearse…The only transportation was buggies and horseback. The horse-drawn hearse edge [sic] close to the grave, and the pallbearers dismounted. They deftly carried Elmer's coffin, adorned with a spray of white lilies to the gravesite…A Dolese cement truck poured two and one-half yards of concrete on the top of the coffin. Elmer had finally reached his permanent home, and the concrete was used to make sure he stayed there…It took him sixty-six years to find his home.[18]

It may not have been home, but it was his final resting place after a very strange journey.

When a bank is robbed, it is logical that the gathering lynch mob is after the robbers, but once in a great while, the mob is after the bank president. Such was the case in Scott City, Kansas. The "robbery" of depositors' money wasn't due to a lone bandit or a gang of outlaws—it was due to a bank failure. "In Scott City in October of 1888, suddenly, without any warning to the public, one of the principal banks of Scott City failed."[19]

The precise cause of the failure wasn't noted, but Mother Nature certainly was responsible for part of the problem. The Great White Ruin of 1885–86 and the Big Die-Up of 1886–87 were followed by another killer blizzard in January 1888. These winter storms swept the prairies and plains, killing hundreds of thousands of livestock and even many people. Ranchers and settlers suffered devastating losses from which they never recovered. In addition, back East, the general financial condition tightened the money supply. Consequently, the bank failed.

> There was a lot of bitter resentment among people who had lost money from the bank failure. The bank president was a former cattleman, and the cashier had promptly disappeared, and feelings ran so high against the president that he came very near to being hanged. In fact, a mob gathered in Scott City one day for that purport, and would in all probability have strung

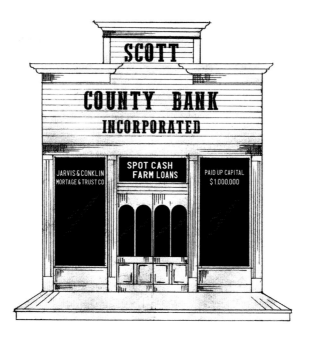

An artist's illustration of the Scott County Bank. When the bank failed, the citizens attempted to hang the bank's president. *Illustration by Chuck Beemer.*

him up on one of the telegraph poles down at the railway depot (There were no trees yet big enough) had it not been for a Mr. Pitts of Modoc, a tall, dignified and highly respected Quaker. He pushed his way into the crowd of angry men to a place where he could be heard, and then reasoned with the men and begged them not to do any violence. Such a murderous act wouldn't bring them back their money, he told them, and as soon as he had finished speaking, the sheriff—Civil War veteran—who had been hastily summoned from his work as a printer, armed with a revolver stepped up on a wooden drygoods [sic] box and in a loud and imperious voice called out, "I hereby appoint every man within the sound of my voice as my deputy. Refuse to serve at your peril!"

Of course as deputy sheriffs, they were obligated to uphold the law and protect the president from mob violence, and that unexpected turn of events cooled the men and soon dispersed without any violence.[20]

The president had been manager of a large cattle ranch in Scott County that was ruined by the big blizzard. His next managerial job was president

of the bank, where he had inherited a lot of bad loans. Obviously, though, he was probably better at riding herd on cattle than on depositors' money.

Cheyenne County, Kansas, is located in the farthest northwest corner of the state with the Nebraska state line on the north and the Colorado state line on the west. Within a radius of sixty-five miles lie the sites of many historical events during the settlement of the trans-Mississippi prairies and plains. The famous historical figures who trod this rugged country were as rugged as the land itself.

To the south is the Kidder Massacre site and Fort Wallace; to the north lies Benkelman, Nebraska, where George Custer and the Seventh Cavalry camped; and to the west is Beecher Island, where fifty scouts held hundreds of Cheyenne warriors at bay for nine days. This is where the famous Cheyenne warrior Roman Nose was killed. To the northwest is the site of the battle of Summit Springs, where General Carr captured and destroyed the Cheyenne village of Tall Bull.

These men, whether winners or losers, were hacked from some mighty tough cloth. Seemingly, sometime during the following generations, a few men of Cheyenne County were cut from an inferior material. Their stories were preserved by the Cheyenne County Historical Society in its book *The History of Cheyenne County, Kansas.*

Frank Fladung and his brother-in-law John Herklotz, wearing neckerchief masks, entered the Farmer's State Bank at Wheeler on April 7, 1922, and proceeded to rob it of $381.25. They locked the cashier and a salesman in the vault before making their escape. The escape was a short one because they got off the main road and had to stop at a farmhouse to ask for directions.

Law enforcement officers followed them to the farmhouse, and the pair "surrendered without opposition when covered with officer's guns. Both men were sentenced to serve ten to fifty years for the robbery."

Nine years later, on June 29, 1931, the Security State Bank in Bird City was robbed by two men.

> *The night before the robbery, one of the men entered the building. In the morning, as the* [bank] *officers and employees entered, they were forced to the back room and tied hand and foot.*
>
> *When the time lock on the vault allowed it to be opened, Edgar Robertson (Assistant Cashier) was made to open it. A little over $700.00 was scooped up and the employees were locked in the vault.*

> *The Postmaster came into the bank shortly after the robber left, and heard the calls of the imprisoned people. They were freed about ten minutes after the bandit left.*[21]

The robbers had a ten-minute head start in a stolen automobile, which was later found. At this same location, another car had been parked along a country road, which raised suspicion of the local farmers. Officers were called, and "nearly all the money taken was found in a field in the northeast part of the county. It had been placed under an old dishpan and pushed down into the ground as far as possible."

The two outlaws, Chester Morris and Elza Harmon, turned out to be two boys who had been working for farmers near Bird City. They confessed to holding up the bank and were sentenced to the penitentiary at Lansing, Kansas. The two began serving their time nine days after the robbery.

Just over a year later, on July 19, 1932, the First National Bank of St. Francis was robbed by a lone bandit in a bold daytime heist. The robber, without any mask or disguise, handed Bertha McNitt a strange note:

> *"Here is to you friendly and do what God loves for this is a holdup and do what I mean for this is a bottle of Nitro Glyserine* [sic]*. For if not I will blow the whole Works of us up and I mean business. Yours Truly. Make it snappy."*
>
> *The man did not wait for the note to be read before he stated what he wanted. He then turned his gun on Mr. Harrison, a customer and made him walk around the railing with the employees. He produced a sugar sack and asked Beth Conway to put the money in it. She stated she did not work there, so Mrs. McNitt was called upon to fill the sack.*[22]

A traveling salesman who stepped into the bank during the robbery defied the gunman. He was able to escape and gave the alarm that the bank was being robbed. The robber locked the employees and customers in the vault before exiting the bank and walking west and shortly began to run toward the Gettle elevator.

> *He was on his way when he was stopped by a car and the men asked him about the course of the robber. They found out they were talking to the robber himself.*
>
> *There was a brief gun battle after which the robber dropped his gun and surrendered.*
>
> *The money was recovered from inside the robber's shirt and he was placed in jail.*

> *Two more men were questioned as being accomplices, but their involvement was not certain.*
>
> *This robber was caught less than fifteen minutes after committing the robbery, and he was assured of a term in the penitentiary.*[23]

Outlaw Joseph Sanford's fifteen minutes of fame ended before he could spend even a penny of the $2,000 he had stolen from the bank.

A bank on a military base probably wouldn't be most people's choice for an armed robbery. Nevertheless, on the cold winter night of Friday, January 8, 1918, with about six inches of snow on the ground, a man armed with a handgun and a hand axe proceeded to loot the bank at Camp Funston after attacking and tying up the five people in the building. He then fled the bank with approximately $62,000. The scene of the crime inside the bank resembled a violent battlefield encounter.

Camp Funston is on the Fort Riley Military Reservation located near Junction City, Kansas. Fort Riley was established in 1854 and was a major base for training soldiers during the Civil War, the Plains Indian Wars and World Wars I and II and is still active today.

The United States had entered World War I in 1917, and Camp Funston was the largest of sixteen divisional cantonment training camps to house and train soldiers for military duty. The George A. Fuller Company was contracted to build the camp with construction beginning in July and completed in September of the same year. Those few months saw nine hundred buildings completed and turned over to the army. Eventually, it became a city with over three thousand buildings, its own power plant, paved streets, electrical generators, plumbing and so forth.

> *A unique aspect of Camp Funston was an area known as the Zone of Camp Activities, commonly referred to as Army City. This four-block-long area was financed and built with private capital and provided soldiers with recreational and other facilities including theaters and an arcade with refreshment booths, general merchandise stores, a fifty-chair barber shop, a seventy-table pool hall, library, and society building housing the YMCA, Knights of Columbus, and a YWCA Hostess House.*[24]

Most of the forty thousand soldiers training for trench warfare no doubt occasionally entertained thought of a horrible death on the battlefields of France where Allied soldiers were dying by the hundreds of thousands. However, because of the small-town atmosphere of Army City, it probably never crossed their minds that a vicious, gory murder of four men could happen on their very doorstep.

Military police immediately blocked all the roads leading into and out of the base and began an investigation of the crime. The robber had killed four of the five bank personnel, but it was discovered that one of the bank employees was still alive. As soon as possible, they interviewed the survivor, Kearny Wornall. He gave this account of the events at the bank:

> *Wornall, in describing the murderer, said a man came to the door of the bank about 8:30 o'clock last Friday and rapped insistently. He was admitted, and covering the five men…with his revolver, forced Wornall to tie the hands of the four men, after which he tied Wornall's hands. The man then looted the bank safe and had reached the door when Winters said to Wornall: "you recognize him, don't you?" Wornall answered that he did. The murderer turned to Winters and said: "You know me, do you?" "I sure do, you black scoundrel," was Winters's reply.*[25]

The man he identified was Captain Lewis R. Whisler. About a year before this incident, he and his wife had divorced. At the time of the robbery-suicide, his former wife and their fourteen-year-old son were living in Salina, Kansas, and his parents were living in Goodland, Kansas.

Captain Whisler had fought in the Spanish-American War and later saw service in the Philippines. Then, anticipating war with Germany, he attended officers' training camp at Fort Riley, Kansas, and was commissioned a captain. He was thirty-six years old.

"Why did this happen?" was the thought on everyone's mind. One contemporary writer gave this reason why Whisler robbed the bank: "The whole case is outside the realm of ordinary thinking…It would be more restful to liken it to the case of the 'certain man of the country of the Gadarenes over against Gallilee,' [*sic*] from whom the Master of Men drove an unclean spirit into the swine, and 'the herd ran violently down a steep place into the sea.'"[26] This was the explanation of a writer who tried to give a "why" to a very bizarre incident and who finally felt compelled to conclude that the act was caused by other-world forces.

Gunslingers to Gangsters

A more believable reason might be $475,000.00, which was scheduled to be shipped to the Camp Funston bank that very day. This would be over $7,351,710.26 in today's money,[27] and besides, there were written reports that the bank was very unprofessional in its operation. Just days before the robbery, a report was filed that the bank employees had not put the currency into the safe and had even failed to close and lock the safe before leaving the building. It was also reported that the large shipment was delayed a day and didn't arrive until after the robbery.

Most newspaper accounts stated that Captain Whisler gained entrance to the bank by rapping on the locked door until it was finally opened because he was an officer. But if it was dark, seven to eight o'clock, and he was wearing an overcoat as one account suggests, would he have been immediately recognized as an officer? Another account reported that the door was unlocked, allowing Whisler to simply walk in.

Why did some newspaper accounts report that Whisler was armed with a revolver but a journal account, published later, stated that he was armed with an automatic pistol?

Why did some report that the money was discovered in the wall of Whisler's office while another account stated that the money was never found? Apparently, believing the money was lost, the owner of the bank immediately sent $50,000 to the Camp Funston bank as part of his plan to replace the loss.

Another question is why did Whisler choose to shoot himself in the head with a military rifle if he had a revolver or automatic pistol? It would be much, much harder to shoot oneself in the head twice with a rifle that would require the bolt action to be worked to extract the spent shell casing and put a live round in the chamber and then again place the gun to one's head and pull the trigger. The suicide weapon was mentioned in several accounts, but one account simply mentions that he shot himself in the head twice without mentioning the weapon used.

Why did he hack to death the four employees and seriously injure the fifth with the hand axe instead of shooting them with the handgun? Could it be that he didn't want the gunshots to be heard, which would quickly bring the military police since there was a sentry walking a beat close by? It appears that the hatchet killing was premeditated.

The facts don't give us the answers, but if indeed Captain Whisler wanted to commit suicide only until he had "sufficient reason," his search for a reason was certainly granted on that cold winter night on a Kansas military base with thousands of soldiers nearby.

3
Wrong Career Choices

"If men could learn from history, what lessons it might teach us! But passion and party blind our eyes, and the light which experience gives is a lantern on the stern, which shines only on the waves behind us!"[28]

"Real knowledge is to know the extent of one's ignorance."[29]

Of course, humans have been ignoring the lessons of history since the beginning of time and sincerely believing they know more than they actually do. Occasionally, there come along some individuals who really excel at these faults. Take, for instance, the two men and one woman who attempted to rob two different Kansas banks in the early morning hours of March 24, 1917.

Their attempt to rob the First National Bank of Overbrook, Kansas, resulted in a lot of noise, a lot of damage and a lot of nothing for the burglars. Sometime between one and two o'clock in the morning, three men tried five times to open the safe with nitroglycerin charges that did $2,500 damage to the bank itself, but the safe still guarded its contents of $10,000, which remained untouched behind the second inside door. The blasts did rip the outer door off the safe, destroy furniture and fixtures and break plate-glass windows.

The robbers had cut the telephone wires, but they hadn't counted on Miller Burress to be on the street about three blocks from the bank. When he heard the first explosion, he ran toward the bank and then heard a second explosion.

Burress did not approach nearer but began shouting for help. He attempted a ruse which worked successfully. He attempted to make the bandits believe that the town was already organized.

"Five of you men go south, the rest of you go down that street there. Now come here fellows and watch this street," he shouted.

Burress gave orders like he was placing forty or fifty armed men at advantageous points around the bank. The lookout, standing in front of the bank reported to the men inside and after a fifth charge had been exploded all three rushed out of the bank, jumped into the automobile and drove out of town.[30]

The attempted robbery of the Kelly State Bank at Kelly, Kansas, was carried out in a similar fashion. On the evening of March 24, the citizens noticed a black touring car with two passengers driving the streets of town. After the robbery attempt, the citizens believed these men were casing the bank.

Later that night, prior to the robbery attempt, the car pulled up to the telephone office, and one man jumped out and began cutting the wires. Immediately, the switchboard failed to work, which prompted the operator to open the outside door, only to be met by a masked man with a gun. "Get back," he was told. "Get back inside, or I'll blow your d— head off!"[31]

Soon, residents of the town heard four blasts as the bandits detonated four charges of nitroglycerin in an attempt to open the bank's safe. Two armed men stood guard outside on the street, and a woman sat at the wheel of another car. The following morning, officials discovered a woman's footprints near railroad tracks where the bandits apparently found tools to pry open the bank's door.

After the bandits left, the cashier of the bank arrived on the scene and determined that the explosions had wrecked the interior of the bank and that the safe had also been blown open. The stolen money consisted of about $250 in gold and silver and more than $600 in paper money. However, there was some paper money left in the safe and scattered about the interior. This currency was so badly mutilated that the authorities believed that any taken by the robbers would also be badly mutilated, making it almost impossible for the robbers to spend, and if they did, it would provide clues to where the bandits had been.[32]

The two banks were believed to have been robbed by the same gang of robbers because of the similarities in the way they worked. Even if they could spend some of the currency, it would have been slim pickings for seven or eight people—hardly worth the risk and effort.

Now, what could the bandits have learned from history to increase their chance of being more successful? The history of banking reveals that there was a back-and-forth struggle between building a better safe for holding the valuables of the bank and developing a better locking device that was equal to the container.

First in this evolution of safes for banks to protect gold, cash or important documents was often a wood box covered with metal, which appeared to be very impenetrable but in reality could be breeched with a hammer and chisel or a strong crowbar. It was easier to break into the safe than to pick or break the lock. When the safe design became superior to the lock, the bandits or burglars developed skills to beat the lock.

When safes couldn't be breached with common tools and the lock couldn't be picked by professional thieves, they resorted to dynamite or nitro to blow open the safe or vault. Safes or vaults were not all created equally, and knowing the difference was essential for the bad guys, as demonstrated by the attempts at Overbrook and Kelly.

This safe and vault evolution continued until it reached an astounding degree of protection. Perhaps the finest example of this were vaults manufactured by the U.S. firm of Mosler Safe Company. In 1925, the Teikoku Bank of Hiroshima, Japan, installed a Mosler vault and safe. This bank was located 360 meters (390 yards) from the hypocenter of the atomic bomb dropped on that city on August 6, 1945.

The building that housed the bank was rebuilt around the vaults, and in 1950, an official of the Teikoku Bank wrote the Mosler company a letter that, in part, stated:

> *As you know in 1945 the Atomic bomb fell on Hiroshima, and the whole city was destroyed and thousands of citizens lost their precious lives. And our building, the best artistic one in Hiroshima, was also destroyed. However it was our great luck to find that although the surface of the vault doors was heavily damaged, its contents were not affected at all and the cash and important documents were perfectly saved...Your products were admired for being stronger than the atomic bomb.*[33]

There was also a lesson here for all banks and bankers. According to John Mosler, vice-president of Mosler Safe Company of Hamilton, Ohio, "Seventy-five per cent of all safes in use today [1951] are potential 'ovens' that can turn assents [sic] into ashes, noted safe expert and record protection specialist warned…To stress the danger of this situation, he cited this conclusion from a

recent survey: 'Of all firms which lose their records by fire, 43 per cent never reopen their doors. Of the firms which remain in business, 14 per cent suffer a reduction of 30 to 66 per cent in their credit ratings.'"[34]

So the evolution continues with both the bankers and the crooks learning lessons and adjusting to the changing challenges.

A robbery on April 30, 1884, would make a textbook script of a western movie or TV episode because what would be portrayed on the screen actually happened in a small Kansas town.

Opening scene: The dusty street of a western cow town is flanked on both sides by stores with high false façades and signs that announce they purvey anything a lonely, thirsty or rowdy trail hand could desire. On the far end of the main street, across the railroad tracks, longhorn cattle fill the loading pens or graze on the surrounding prairie.

Amid the sounds of creaking wagon wheels, plodding hooves and cussing teamsters, two pistol shots ring out, and a figure stumbles off the sidewalk into the street and collapses. He rolls over on his back and tries to raise his Colt Peacemaker before dying with his sightless eyes staring at the prairie sky. The noonday sun winks off a marshal's badge pinned to his vest next to a red stain on his shirt.

This marshal was one of several lawmen who died trying to tame this town. It was just one of the killings and general hell-raising that prompted a Wichita editor to write, "As we go to press hell is again in session in Caldwell."

Caldwell, Kansas, was established in 1871 and became a shipping point for Texas cattle drives when the Santa Fe Railroad tracks reached the town in 1879. It quickly gained fame as a wild and woolly cow town that soon became known as the "Border Queen" because it sat just on the Kansas side of the Oklahoma border. Some say that during its heyday Caldwell had a higher murder rate and lost more lawmen than any other cow town. Between 1879 and 1885, eighteen city lawmen were gunned down on its dusty streets or in one of the rowdy saloons.

In July 1882, the Caldwell City Council appointed Henry Brown assistant city marshal. He was appointed city marshal in December of the same year. Several weeks later, an old friend of Brown, Ben Wheeler, came to town and was appointed assistant marshal. The two lawmen quickly began to tame the town, and it isn't surprising that the town folks were thankful.

Gunslingers to Gangsters

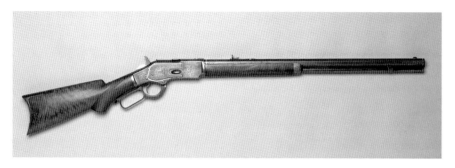

The presentation Winchester rifle given to Marshal Henry Brown by the city of Caldwell, Kansas. Brown carried it when attempting to rob the Medicine Lodge, Kansas bank. *Kansas State Historical Society.*

So thankful, in fact, that on January 4, 1883, they presented Brown with an engraved, gold-plated Winchester rifle for his service to the community.[35]

Now the scene changes to Medicine Lodge, Kansas, which gained notoriety in October 1867 when the U.S. government and the Cheyenne, Arapaho, Comanche and Kiowa tribes gathered to negotiate a new treaty. There wasn't much trust on either side, and in reality, the treaties reached at that time failed to end the wars between the Indians and whites.

Despite the treaty's failure, the location became the site for the town of Medicine Lodge, which was incorporated in 1879. It sits just north of the confluence of Elm Creek and the Medicine Lodge River. As the crow flies, it is approximately seventy miles northwest of Caldwell.

On April 30, 1884, the scene's focus narrows to four men riding into Medicine Lodge during a heavy rainstorm. They came from the west and tied their horses to the Medicine Valley Bank's coal shed located just behind the bank. The bank had just opened, and the cashier, Mr. Geppert, was doing paperwork while bank president E.W. Payne sat working at his desk. Three of the riders entered the bank through the rear door. The bandits ordered the men to throw up their hands, which the president did, but the cashier pulled a revolver, which prompted four shots from the robbers; two bullets hit and killed cashier Geppert while a single bullet critically wounded Payne. The city marshal, who was nearby, heard the shots and opened fire on the robbers, causing them to abandon the robbery and make a hasty retreat out of town.

The scene now turns to the obligatory pursuit by a posse pounding after the robbers. In this case, the posse was a determined group of well-mounted and well-armed citizens. The posse sighted the bad guys just beyond the Medicine Lodge river crossing south of town. A running gunfight followed,

and the robbers were forced to abandon their horses after one of them could go no farther. The holdup men made their stand in a canyon some three or four miles southwest of town. A worse place for a final stand and shootout would be hard to find. The four bandits were at the bottom of a "bowl" with the posse on the high ground. During the standoff and gunfight, a couple of the posse returned to Medicine Lodge for reinforcements. Part of the reinforcements apparently were barrels of kerosene that they intended to pour into the bowl, which by this time had flooded from the heavy rain.[36] The posse evidently intended to roast the bank robbers, but the outlaws surrendered before the roasting could commence.

Now comes the plot twist: the outlaws were none other than Caldwell's marshal Henry Brown; his deputy, Ben Wheeler; William Smith, a T5 (ranch brand) outfit cowboy well known in the area; and John Wesley, another well-known cowboy.

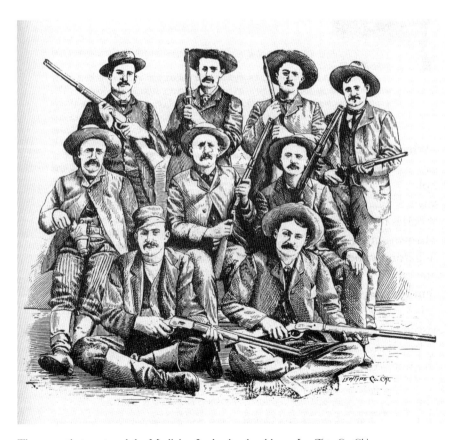

The posse that captured the Medicine Lodge bank robbers. *Levy Type Co. Chicago.*

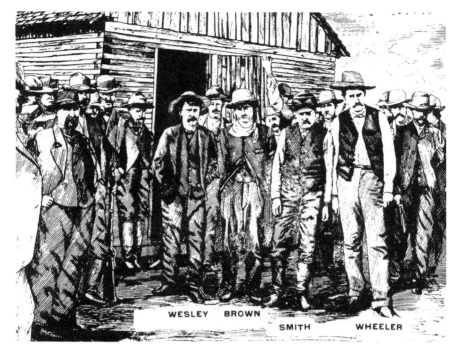

Medicine Lodge bank robbers after their capture by the posse. *Levy Type Co. Chicago.*

What Marshal Brown had failed to mention to the Caldwell City Council was that he had ridden with Billy the Kid during the Lincoln County unpleasantness and the Kid's ambush at McSween's Store during raids in New Mexico. Later, it was suspected that his gang was responsible for other robberies in the area where they apparently worked both sides of the law.

Brown and gang were escorted back to the town jail, where another obligatory scene played out: angry residents surrounded the jail and were determined to pass sentence on the murders, crying, "Hang them, hang them!" The armed crowd demanded the prisoners, but the sheriff refused until he and the posse were overpowered and the jail doors opened. The prisoners knew what awaited them, so in desperation they made a bid for freedom. Brown ran a few steps and fell dead as numerous gunshots rang out. Wheeler was wounded, and the other two were grabbed at the jail door.

Smith, Wesley and the wounded Wheeler were taken to an appropriate tree east of town. After the doomed were given a moment to say any last thoughts, they were left swinging at the end of ropes. Justice was served frontier style.

The scene shifts to the story's obligatory romance: after Brown was jailed and before the mob opened the jail doors, he wrote a letter to his wife, whom he had married after moving to Caldwell. History records that Brown did not drink, smoke or chew. He and his wife had bought a house in Caldwell. His letter read:

Medicine Lodge
April 30, 1884

Darling Wife: I am in jail here. Four of us tried to rob the bank here, and one man shot one of the men in the bank, and he is now at his home. I want you to come and see me as soon as you can. I will send you all of my things and you can sell them, but keep the Winchester. This is hard for me to write this letter, but it was all for you, my sweet wife, and for the love I have for you. Do not go back on me; if you do it will kill me. Be true to me as long as you live, and come to see me if you think enough of me. My love is just the same as it always was. Oh, how I did hate to leave you on last Sunday eve, but I did not think this would happen. I thought we could take in the money and not have any trouble with it; but a man's fondest hopes are sometimes broken with trouble. We would not have been arrested, but one of our horses gave out and we could not leave him alone. I do not know what to write. Do the best you can with everything. I want you to send me some clothes. Sell all the things that you do not need. Have your picture taken and send it to me. Now, my dear wife, go and see Mr. Wezleben and Mr. Nyce and get the money. If a mob does not kill us we will come out all right after a while. Maude, I did not shoot anyone, and did not want the others to kill anyone, but they did, and that is all there is about it.
Now, good-bye, my darling wife. H.N. Brown[37]

The scene changes again to a young woman sitting in a rocking chair weeping over a letter that has fallen from her hands onto her lap.

Brown's prized Winchester rifle was stolen before his personal items could be sent to his wife. This gun has now been acquired by the Kansas State Historical Society in Topeka, Kansas.

Bank burglary, fast automobiles and some drugs just don't mix. Proof that should make that abundantly clear is found in the story of a bank burglar

named "Blackie" who, along with two others, attempted to rob the First National Bank in Dighton, Kansas, on the night of June 27, 1922.

Dighton, located in Lane County, is a typical small rural town twenty-five miles east of Scott City. Arle Boltz was an employee of the bank and was a member of the posse that captured the burglars. Boltz described Dighton as "a real sleepy town. All electricity was turned off at 12:00 p.m. and street lights were turned off at 11:00 p.m. and there was no night watchman."[38]

The July 7, 1922 issue of the *Dighton* (Kansas) *Herald* under the headline "Bandits Identified" ran over ninety column-inches of copy in an effort to correctly record the events of the bank robbery:

> *Bandits has been the talk in Lane county* [sic] *for the past week. Baseball and harvest have been forced to take a back seat and wild and weird are the stories that have been afloat.*
>
> *Last week we had to hurry our story so much in order to get the type set that many important details were left out. This was partly due to the fact that everyone was so excited that they were hard to talk to. There were so many versions of the battle that we could not arrive at any definite conclusion. It is human nature that no two persons can see the same thing alike and had we been an actual eye witness we would undoubtedly have had a version all our own. If in reading these notes you see a report that does not conform exactly with the way you saw it, please refrain from thinking we are trying to string some one and remember that this is the way some other man's eyes recorded the event.*

The rest of the story unfolded like a novel that began with a life of crime for the three burglars who made their appearance in Dighton on that Monday evening. They were noticed at a camping ground near the city but didn't appear to be preparing to spend the night there because they didn't pitch a tent or prepare a campsite.

Later, the same car was observed cruising about town and then stopping in front of a store where the occupants got out and then sat down on the sidewalk in front of the store. Much later in the evening, three men were seen on the east side of the bank building. At this time, no one had connected all the dots.

However, it was only a couple hours later that events began to unfold that connected all the dots with the three men who had been seen around town the previous night. About two o'clock on Tuesday morning, the alarm on the bank began to sound, which awakened many residents who dressed, armed

themselves and rushed toward the bank. This was done quickly, but it did allow just enough time for the bandits to get a head start on the posse.

A bank employee entered the bank expecting to find that the alarm had malfunctioned as it had done in the past. But when he encountered a hole in the vault's brick wall, he ran outdoors expecting a charge of explosives to go off any minute. Outside, he fired three shots in the air, which was a signal to let the town know that a robbery had occurred. Another bank employee who lived just outside town was running toward the bank when a car went by at a high speed. Although armed, the employee didn't fire for fear of hitting some innocent person. He did fire one shot, letting the others know that he was on his way. Apparently, the town had a well-planned method of signaling in times of emergency. Also the telephone exchange began to notify the community that a bank robbery had taken place and to be on the watch for the bandits fleeing in a black touring car.

Back at the bank, no explosion occurred because the alarm had sounded before the burglars could gain access to the vault where they may have used explosives to get through the metal wall of the vault. The sheriff quickly organized four cars full of well-armed men, who roared out of town on the trail of the black touring car with three burglars who were doing their best to throw off the pursuers.

Law enforcement back then didn't have cellphones and satellite imaging, but it did have an ingenious method of helping keep track of the bandits, which in this case worked to perfection. In the 1920s, there could be as many as four sets of farm buildings on a section of land, and most of them had a windmill that could serve as an observation post for the community.

The man of the house would climb up the windmill tower and report down to his wife if he saw any autos on the roads. She would then call the sheriff's office and report any sightings. The evening of the robbery attempt, a light rain had fallen, which made following the tire tracks in the dirt roads easy. That, coupled with the sightings from the community, helped the sheriff and posse stay on their trail but always about thirty minutes behind, as the bandit changed directions and backtracked in order to confuse any pursuit.

The burglars were driving a new Marmon touring car that they had stolen from an auto dealership in Tulsa, Oklahoma. The Marmon was a well-designed and well-engineered automobile with a reputation for speed that made it a favorite of some bank robbers. It was said to be able to cruise a gravel road at ninety miles per hour. Apparently, there were no specs available to the driver as to how fast it could negotiate a square corner. They failed to negotiate such a turn and crashed into a telephone pole and

rolled the Marmon. When the posse arrived on the scene, they examined the wrecked auto and discovered a lot of blood on the car's interior and knew that some of the bandits were injured. At this point, it became a foot search over some pretty wide-open spaces.

As it turned out, a little girl and a windmill led to their capture. After observing the older folks climbing the windmill to look for the burglars, little Willetta Finkenbinder climbed the windmill and told her mother that she saw the three men crawling through the wheat field on their farm. The mother didn't believe the daughter but climbed up to have a look. Sure enough, there were three men crawling through the wheat field some distance from the buildings.

Hurrying down from the windmill, she rang the wall telephone and spread the news, which brought the posse in minutes. Spreading out and approaching a clump of weeds the outlaws were said to be hiding in, the posse was met with a hail of bullets that the newspaper described as sounding "like machine gun fire. It was put-put-put, just a steady stream of death-dealing bullets. In the first of the firing Bradstreet fell. He was immediately loaded into the Durr car and carried back to safety, where he could get medical aid."[39]

This didn't discourage the posse members, and they responded with their own gunfire. Then one of the men in the weeds stood up, began firing and was riddled with bullets from the posse. He was dead, and soon the other two men surrendered. The captured men were taken by the sheriff and his deputies to Ness City, where the prisoners were given appropriate medical attention before being taken to Garden City and placed in the Finney County Jail. As for Blackie:

> *When the car carrying the dead man arrived in town, pandemonium reigned. Every one wished to view the bandit. It was with difficulty that the car proceeded up the street from the Hotel Dighton to the First National Bank, where he was unloaded and taken to the undertaking rooms upstairs.*
>
> *A steady stream of the curious filed up and down the stairs all that afternoon, eager for a look at the bandit…Sheriff Richardson of Finney county* [sic] *took the dead man's finger prints and a photograph was taken. These were sent to Leavenworth to the bureau of criminal identification of the federal prison.*[40]

When the dust settled, it was learned that the dead man was called Blackie. However, his real name was Thomas Martin, and he had family

in Pennsylvania. Why he was called Blackie is unknown. The two men who helped Blackie in the burglary were C.H. Barton and Arthur Lang. Barton lived with his wife in Sapulpa, Oklahoma, and Lang gave his address as Kansas City. All three had used various aliases during their criminal careers, and all three had served time in different state penal institutions.

Evidence was found that implicated the gang in the burglary of the Fowler bank on Friday night and the Winona bank on Sunday night before driving to Dighton to rob the bank there.

A drug kit containing a syringe and three vials with three different powdered substances was found at the crash site, and it was assumed it belonged to one of the burglars. Besides the syringe, the three vials contained powders of nitroglycerin, strychnine, caffeine and sodium benzoate. All these substances were used in medical remedies in the past. The kit's purpose has remained a mystery, but it may have been used in past burglaries to blow a safe, or it could have been carried for medicinal reasons. No additional references were found to the drug kit except a note in the display at the Lane County Museum where it was labeled a "Dope box with syringe and pep dope taken from Dighton bank Robbers June 1922."

The passing of time can certainly change people's views of the past, and sixty-nine years later, the town of Dighton had seemingly forgiven Blackie and his gang. Immediately after the bandits were killed or captured, Blackie's body was displayed in front of the bank he'd tried to rob. It was reported that local citizens clipped some of Blackie's hair to keep as souvenirs.

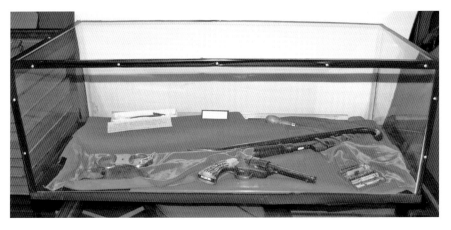

Items taken from the robbers after a failed bank robbery in Dighton, Kansas, include a .38 Colt revolver; handcuffs; a dope kit containing nitroglycerin, strychnine and caffeine; plus miscellaneous other items. *Courtesy Lane County Historical Museum. Photo by author.*

Since no family members claimed Blackie's body, it was buried in Dighton's Potters Field, where the site was marked only with "a small irregular shaped rock." Years later, a series of events prompted Bill Ragel of Ragel's Monument Service in Garden City to replace the small rock. Ragel said he believes it sacrilegious for anyone to be buried without a headstone and that "every tombstone is a part of a communities [*sic*] history."[41] So he donated a headstone for Blackie's grave, and since that day in June 1991, Blackie's resting place has been graced with a tombstone to remind people of that historic day in Dighton.

4
Amateur Yeggs and Unsolved Robberies

In the early morning hours of February 1911, a gang of four men made history in the annals of bank robbery. At the time they may not have been thinking of history as much as the loot in the safes of the Citizens State Bank and the State Bank of Waterville in Marshall County, Kansas. One thing they did have to worry about was armed citizens and the law because this was an era when citizens often responded to crime with revolvers, rifles and shotguns.

Several of the bolder citizens, including T. J. Wolverton, came on the run and reached the scene just as the robbers were leaving the bank with the loot. Wolverton fired two shotgun blasts at the robbers and then became the target of their revolvers. The next morning there were at least a dozen .38-caliber empty brass on the street. Thankfully, the citizen was unharmed, and apparently the shotgun didn't do any damage to the robbers.

However, not all responded as the above. At one of the town's restaurants, a farmer who came into town to catch a train to St. Joseph, a group of young men who had been to a dance and the cook all turned out the lights and dove under the counter when the first explosion rolled down the street.

Newspaper copy reported, "One feature of the robberies was that for the first time automobiles were apparently used by the gang of thieves to make a getaway."[42] Sheriff Jim Sullivan and his two deputies, Mike Nester and Fred Munson, decided their trusty horses probably weren't up to this challenge, so he procured an automobile and drove to the bank to investigate. They decided that there were probably four men involved, including one who had used explosives to blast open the safe.

Sheriff Sullivan's investigation concluded that an Irishman named Dan Carney; another man named Wheeler, who was reportedly an expert with nitroglycerin; and a man named Henry Hoerr were likely the yeggs.[43] These three had been seen in the town of Wymore prior to the robbery. He also concluded that bank robberies at two towns within miles of the current robbery—Beattie the previous November and another at Hanover in December—were also probably the handiwork of this gang. Newspaper copy stated, "This act of plain gall enraged the sheriff."[44]

Marshall County had proved good picking, for the gang had robbed the Hanover bank and the Beattie bank, which were both within sixteen miles of Marysville, the county seat. Considerable loot was taken from both of these banks. However, the third bank at Waterville had thwarted a previously attempted robbery some years earlier, and this time the heisters didn't bother the Merchants State Bank.

Sheriff Sullivan kept on the trail of the gang and in a few months had arrested Neil Mulcahy, Dan Carney, Henry Hoerr and Alex Menard, who all went to trial. It took the jury just twenty-three minutes to bring back a verdict of guilty.

The historical part of the robbery was robbing two banks at the same time. The Dalton gang failed gloriously, famously and tragically in 1892. For twenty years, apparently no one tried, or succeeded, until the winter of 1911–12, when these four men simultaneously robbed the Citizens State Bank and the State Bank of Waterville in 1912. The haul was $3,000 from one bank and $4,000 from the other.

That may not seem like a large haul, but unlike the Daltons, they escaped with the loot and lived to rob another day. The average income in 1912 was $1,033, so that $7,000 represented the income for the average wage earner for a period of over six years. The cost of a medium-priced home was $2,700, so the burglars could have purchased two homes and had enough left over to purchase two new Ford Runabout Model T automobiles, which would have cost them about $590 each. They would still have $420 left over to buy seven-cent gas, fifteen-cent-per-pound rib-eye steaks and whisky at $2.50 per gallon. Or $7,000 would have bought a quarter section of the best farmland anywhere in Kansas.

In 2015, the average median family income is about $53,000, so to equal six years of average income would take $318,000. Cash needed to purchase two medium-priced homes in Kansas would probably be close to $300,000, and two new Ford Fiestas would add $27,930 to the tab for a total of $327,930 with some more needed to buy $3 gas, $12 rib-eye steaks and whisky at $80 per gallon.

To those who didn't like working and waiting, robbing banks could appear as an attractive alternative—until they got caught. As a group, they are apparently extremely slow learners because, after being caught and serving time in a facility of corrections, most of them go right back to robbing banks again.

Many students have worked to help finance their medical schooling, but it's unlikely that many worked at the same job as Dr. Morrill E. Gebhart, who earned his DC degree and set up a chiropractic practice in Kansas City. As it turned out, not only was his job fraught with risks, but so was his marriage and his relationship with another woman.

He divorced his wife during this time and then became involved in a relationship with a female chiropractor who had an office adjoining his in downtown Kansas City. When Dr. Gebhart ended his relationship with the doctor next door and remarried his former wife, things quickly soured due to the fact that the job that helped put him through chiropractic school was robbing banks.

> *The woman in the case was one who became infatuated with him after he had been divorced from his wife for several months. He re-married his wife a short time ago, and the second woman in order to bring about their separation again, went to Mrs. Gebhart, it was said, but the wife refused to believe the accusation.*
>
> *Then, determined that if she could not have him she would not let another woman have him. She is said to have revealed to Wichita officers that Gebhart was robbing banks. The officers then started the check up which resulted in his arrest Friday in Kansas City on a felony warrant charging him with robbing the Cheney bank of $1,800 November 22, 1924.*[45]

The $1,800 in 1924 would be over $24,000 in 2015. Not enough for a medical degree, but there were two other banks that he admitted robbing. The total for the three banks added up to $5,000. The other two banks that he tapped for tuition money were the Valley Center bank in Sedgwick County and the St. Marys bank in Pottawatomie County.

Adjusted for inflation, his take would add up to over $67,000 in 2015 money, which was certainly enough to help cover a large part of his medical

degree in the late teens or early twenties if he had used it for tuition. Apparently, this wasn't the case because he told authorities that the other woman in the three-way equation "had eleven hundred dollars on deposit in Kansas City under her son's name, as her part of the loot."

"The arrest at Kansas City of Mrs. Cora E. Holdren, named by Gebhardt as an accessory in the robbery of the bank at St. Marys, Kan., was almost simultaneous with the sentencing of the doctor-bandit, who led a Jeckyll [*sic*] and Hyde existence here while attending a chiropractic school."[46]

It's hard to state exactly the cost in dollars of Dr. Gebhart's medical education, but one thing we do know of for certain is that it cost him ten to twenty-one years in Lansing.

Reporting on burglary and robbery attacks on Kansas banks in 1924, the *Kansas Banker* ran this copy:

> *During this Association year, May 1, 1924, to April 30, 1925, forty-nine attacks, successful and unsuccessful, were made on Kansas Banks, eleven of which were within the four months, January to April inclusive, 1925. Of these forty-nine attacks 27 were burglary, 19 were hold-up and 3 exterior messenger hold-up…In several instances the bank safe was removed and carried away bodily, looted and abandoned and afterwards located.*[47]

A previous issue of the same magazine identified specific instances when this tactic was successfully carried out:

> *Two remarkable burglaries took place—the Peoples State Bank of Whitewater on the night of October 28th and the Citizens State Bank of Atlanta [Kansas] on the night of October 29th. In both instances the robbers took the safe bodily and removed it to far distant points where the safes were opened, without explosives, by removing the combination and then the safe was easily entered after the timer had run down. The Atlanta safe was found nine miles south of Foraker, Oklahoma, in a secluded place a quarter of a mile from the road among the hills. This safe was a Mosler Manganese. The other safe was an Ely-Norris which in like manner was carried to a secluded point two miles north of Peabody, Kansas, in a lonely dump ground and was opened in the same manner as the other safe the night before.*[48]

Gunslingers to Gangsters

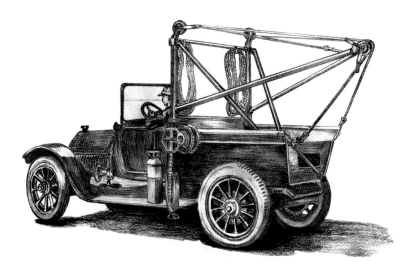

Carrying off a bank safe with a wrecker truck led to an innovative form of bank robbery that evolved into various methods of hauling off ATMs. *Illustration by Chuck Beemer.*

As the banking industry gained begrudging acceptance from the public, it became imperative that banks present an appearance of impressive safety for their depositors. This gave rise to the fortress-like appearance of stone and brick bank buildings that bespoke of impregnability. This thinking fostered the concept of placing the safe, hopefully of a large and modern design, in a window facing the street where it could assure potential customers that their hard-earned money would be protected. This prominent display of the safe also made any attempt to burglarize it visible from the street.

However, the practice by robbers of just hauling off the safe began to change the bankers' thinking about security. Unfortunately, not all banks heeded such advice, and the novel idea caught on and has continued to be used up to the present time.

> *Police Hunt Bank Thieves*
> COLLYER—(AP)—*A wide search over a three-county area was being made by local, county and state law enforcement officers Sunday for the three men who robbed the First National Bank of Collyer June 28* [1962].
>
> *In the burglary, the men hauled away a two-ton safe reported to have contained $7,900. A winch-equipped truck used to haul away the safe was found July 4 about 13 miles west of Ness City.*

> THE MANHUNT was renewed Sunday in Lane, Ness and Trego counties when Kary Brown, a farmer, reported to authorities a breakin [sic] of a farm building on his farm 15 miles northwest of Dighton, Kan.
>
> He said an attempt was made to steal some welding equipment, including a cutting torch. The farmer said he saw three men enter the building but they fled when he fired at them with a 12-guage shotgun.[49]

Even if the men had been successful in stealing the torch, it would probably have done them little good because by 1962, the technology of safe manufacturing had long ago defeated the acetylene cutting torch.

It's possible that these men had some close relatives living in Pottawatomie and Trego Counties, as this newspaper article suggests:

> *Safe Rips Floor, Bank Thieves Fail*
> HAVENSVILLE—Special—Burglars who attempted to pull the safe from the Havensville State Bank sometime Sunday night failed when the heavy safe broke through the floor of the bank.
>
> A winch truck, which had been stolen Sunday from its parking place near Blaine, was being used in the effort to drag the safe from the bank.
>
> W.E. Schane, bank president, said he would not know until later Monday whether any money is missing. He said he believes the thieves got no money.
>
> Havensville is approximately 40 miles northwest of Topeka in the extreme northeast corner of Pottawatomie County…The would-be robbers either were frightened as they attempted to move the safe or abandoned the attempt when it broke through the floor, the sheriff said…Agents from both the Federal Bureau of Investigation and the Kansas Bureau of Investigation were assisting local officials in the investigation.[50]

Apparently, in the robber's mind, hope springs eternal since even today the criminals are still employing the same tactics. The *News-Journal* of New Smyrna Beach, Florida, ran this story on October 25, 2014:

> Two Kansas men were arrested Saturday for trying to steal an ATM machine from Walgreens on State Road 44, police said.
>
> Brian Danna, 27, and Alan Tassell, 31, who police say are transients, are suspected of smashing in the front door of the business just after 1:45 a.m., New Smyrna Police Sgt. Eugene Griffith, the department's spokesman, said in a press release.

> *The men attempted to wrap a chain around the ATM machine and pull it out of the business at 1800 S.R. 44 with a truck. As the alarm sounded, a nearby Volusia County Sheriff's deputy observed the crime in progress, Griffith said. When the men discovered the chain was too short to wrap around the ATM, they fled in a stolen Dodge pickup, with the deputy close behind, according to the release.*

History keeps repeating itself, so in the future, hopeful criminals will probably continue attempting to drag away safes or ATMs.

The name William Quantrill is inexorably linked to Lawrence, Kansas, but now that infamous name has to share the historical spotlight with another infamous criminal, that being Clyde Barrow of Bonnie and Clyde notoriety. Barrow, accompanied by Ralph Fults and Raymond Hamilton, robbed Lawrence's First National Bank of $33,000 in 1932.

What makes this robbery so intriguing is that it isn't mentioned in the early history of Lawrence or, in fact, in any history of the city or anywhere else until John Neal Phillips wrote a book about the life of Ralph Fults that was published in 1996. The book, *Running With Bonnie and Clyde: The Ten Fast Years of Ralph Fults*, was published by the University of Oklahoma Press, meaning that it had peer reviews and professional editing before going to press. Therefore, it is a source to be given some consideration. Of course, not all researchers who wrote about the career of Bonnie and Clyde agree with Phillips.

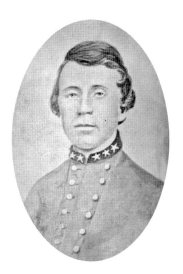

William Quantrill is mostly known for burning and looting Lawrence, not as a bank robber. *Kansas State Historical Society.*

According to Phillips, the book is based on five years of intensive research, more than twenty hours of interviews with Fults, interviews with fifty-eight other eyewitnesses, testimony from police depositions, court transcripts and contemporary news sources.

The book convinced the owner of the restaurant Teller's, located in the original First National Bank building at the corner of Eighth and Massachusetts Streets in Lawrence, that the robbery had occurred. Fascinated by the news that Clyde Barrow had robbed the bank, the restaurant sponsored a reenactment of the robbery, complete with period costumes and the Ford car that was used in the movie about Bonnie and Clyde.

Be that as it may, most Kansans, including Lawrence residents, have never heard of the robbery, and some believe it never happened because there is no mention of it in any newspaper accounts of the time. And there is no police report on file. This lack of validation presents the question: if it really happened, why has local history been silent on the subject for nearly sixty-five years?

Provided that Ralph Fults's recollections are correct, all subsequent reasons for this silence are pure speculation. The bank owner may have wanted to keep the robbery a secret to prevent a run on the bank, which would force its closure. During this time period, banks were failing at a rapid pace that ruined many bankers, stockholders and customers. Some bankers went to great lengths to protect their trust with customers as well as prevent the foreclosure of their banks.

We know this had happened in the past because, following the robbery of the Army Bank at Camp Funston, "William Huttig of Kansas City, Missouri, President of the National Reserve Bank of that city, of which the Army Bank was a branch, announced through Divisional Headquarters at Camp Funston…that the money would be replaced by him, as owner of the bank, and that he already had made good on deposits of $50,000."[51]

It's also known that customers who lost money in the failure of a bank could be angry enough to threaten serious bodily harm to the officers of the bank. An example is the failure of the Scott City bank in 1888, when citizens intended to hang the president of the failed bank.

The president of the First National Bank in Lawrence at the time of the robbery was William Docking, who purchased interest in the bank in 1931. Docking's banking career began in 1881 and spanned seventy-one years.[52] It is certainly plausible that he would have had the resources, influence and friends to replace the $33,000 Barrow, Fults and Hamilton stole in 1932. By doing so, a run on the bank would be prevented and the stigma of an insecure financial institution avoided.

Phillips's book is based primarily on the recollections of Ralph Fults, who "was only nineteen when he first met Clyde Barrow, but he was already a five-year veteran of crime and detention. He had been shot while fleeing

The infamous outlaw duo of Clyde Barrow and Bonnie Parker. *Courtesy Library of Congress.*

from an Oklahoma officer, had escaped from numerous jails and juvenile institutions, and had been brutalized by guards at the State Juvenile Training School, a reformatory in Gatesville. On April 8, 1930, Fults and three other convicts escaped from solitary confinement at Texas's maximum security

Eastham Prison Farm, nicknamed 'the bloody ham' because of the atrocious conditions in existence there."[53] According to Phillips, the only reason that Barrow robbed banks was to secure money and weapons to launch a raid on the prison farm in revenge for the brutal treatment the guard inflicted on the inmates, including Clyde Barrow. On the morning of January 16, 1934, after three and a half years of robbing and planning, Barrow and associates did finally raid the prison, release some inmates and kill two guards.

This raid set in motion the shoot-on-sight hunt for Barrow, who robbed his first bank in Lawrence, Kansas, in 1932. It ended for Barrow, and his girl, in a hail of gunfire on a lonely road near Gibland, Louisiana. Barrow's partner Ralph Fults, on the other hand, got lucky—if being sentenced to two fifty-year terms in Camp 5 of the Mississippi State Penitentiary can be considered lucky.

> *Ralph Fults began serving his two fifty-year terms on September 2, 1935. Although his chances for a parole were virtually nonexistent, he was nonetheless relieved, having escaped both the gallows in Mississippi, and the reprisals of Texas prison officials. His glee, however, would be short-lived.*
>
> *On May 5, 1936, Fults, in utter desperation, led a prison strike at Camp 5 of the Mississippi State Penitentiary, near Parchman. Commandeering the barracks and dining hall, he and the other inmates hoped to win an audience with the governor and expose the many murders and incidents of sadistic brutality perpetrated by the camp manager, whose hatred of Texans was both bizarre and all-consuming. "The whole state's populated with nothin but criminals," he often said. "An electrified fence should be put up along its borders to keep the bastards away from the rest of us." Two of Fults's friends, both Texans, had already been killed. Fults was told that he was next on the list. A strike was quickly organized. Instead of the governor, however, Fults and his band of insurgents found themselves face-to-face with the National Guard…Thus thirty-six hours after it started, the strike ended. Fults was beaten and placed in solitary confinement.[54]*

Solitary confinement did prove lucky for Fults because the National Guard remained at the prison for several weeks to prevent the camp manager from brutalizing or killing Fults. Shortly thereafter, the camp manager was fired and replaced by N.G. Briggs, a retired sheriff from eastern Mississippi, who instituted major changes at Camp 5. After the changes had been in place for a couple years, Briggs called Fults to his office. "Well, I'm getting

along in years," Briggs said. "I don't have much time left. But if I can help just one fellow get himself straightened out in this world, then my life will have been worth it. I'd like to make you that fellow."

Fults did get his life straightened out, and "a conditional pardon was granted to Ralph Fults in January 1944—nine years after Fults had entered the Mississippi State Penitentiary"

Upon his release, Fults tried to enlist in the armed forces. "You've already been to war someplace," said the army doctor as he examined the scars of five gunshot wounds and a knifing. Fults failed the physical exam and was exempted from service.[55]

"From the time of his prison release in 1944 until his death in 1993, Ralph Fults sought to understand the events of his early life, to put into perspective the forces that drove a handful of Depression-era Texas youths beyond the brink of self-destruction."[56]

In 1954, the State of Mississippi granted Ralph Fults an unconditional pardon. He later married, had children, attended church and dedicated his life to helping institute changes in the criminal system and helping youth avoid the road to imprisonment.

All indicators support the fact that Fults's rehabilitation was genuine and lends credit to his statement that he, Clyde Barrow and Raymond Hamilton in fact robbed the First National Bank in Lawrence, Kansas. And considering that law enforcement validated his association with Bonnie and Clyde, his brilliant escapes from maximum-security prisons and his many gunfights with the law, it is difficult to see that lying about the robbery of the Lawrence bank would add anything significant to his reputation.

This robbery was never solved at the time and would have to be tallied in the win column for bank robbers.

The Dalton gang's criminal career was brief, 1890–92, and during those two years, their main focus, and success, was robbing trains. Banks just weren't on their agenda from the reliable information available, although there are many apocryphal accounts of bank robberies by the gang. One of the robberies that has been attributed to the Daltons occurred at Dexter, Kansas, on September 19, 1892, two weeks before the Coffeyville raid.[57] Supposedly, Grat Dalton was recognized by citizens who said there was a second man with Grat but that the second man was a stranger to them. The

take was $3,000, and although Grat certainly was tried and convicted at Coffeyville, neither the other bandit nor the cash from the Dexter bank was ever apprehended.

When the Dalton gang was gunned down in Coffeyville, the authorities found only $500 (some accounts give $800) on the gang members' bodies. Apparently, this was the entire wealth of the Dalton gang, with the possible exception of rumored buried treasure that has not been confirmed. This brings up some interesting points concerning Grat and his partner who robbed the Dexter bank. Where would they spend $2,200 or $2,500 in the two weeks until Coffeyville? Today that may not seem difficult to do, but those 1892 dollars would be worth about $79,000 in today's money.[58] Dexter is approximately seventy miles from Coffeyville, which would be a two- or three-day ride, depending on how hard they pushed their horses. Consider also that there were no malls, supermarkets, restaurants or motels in that part of the country when they robbed the bank.

The event is reenacted each year in Dexter during the Black Dog Indian Trail Festival.

Hindsight isn't always twenty-twenty, and in the case of Henry Starr, it seems not to be. Did he really rob more banks than anyone else? Was he really the first robber to use an automobile in a bank robbery? Did he really rob two banks at the same time, something nobody had ever done before?

He was undoubtedly a very intelligent and charismatic individual who did rob general stores and train depots, as well as banks in IT (Indian Territory) in Kansas, Missouri, Arkansas, Colorado, New Mexico and, perhaps, California.

Henry was born to a family with mixed blood: "I was born near Fort Gibson, I.T., on December 2, 1873, and am of Scotch-Irish-Indian ancestry. My father, George Starr, was a half-blood Cherokee Indian; my mother, Mary Scott, is one-quarter Cherokee. There were three children by their union—Elizabeth, the eldest, Addie, the second, and myself, Henry George Starr, the youngest."[59]

Although his lineage included many hard cases such as Sam Starr, Belle Starr and Tom Starr, Henry didn't fit the stereotypical outlaw hard case. He didn't "use liquor, tobacco, tea, or coffee."[60] But he could run with the toughest outlaws and hold his own because he learned early in his life to be

an expert with firearms, survive in the roughest country without the niceties of civilization and live off the land.

His career in crime began when he was still in his teens and ended in a failed bank robbery when he was forty-seven. He was sentenced to hang by Judge Parker and then pardoned by President Teddy Roosevelt. Henry was also sentenced to scores of years in prisons but because of his exemplary conduct was released after serving only part of those sentences. He used his time in prison to educate himself, which added to his persona as a refined and educated gentleman. He married at least twice, worked a straight job for several years and had a son whom he named Roosevelt.

But the pull of the excitement of criminal activities couldn't be conquered, which ultimately resulted in his return to unlawful activities. On March 25, 1893, Henry, along with a fellow named Frank Cheney, rode into the Kansas town of Caney in Montgomery County with the intent of robbing the Caney Valley National Bank. This would be their first bank robbery, so the two prepared carefully for the heist.

> *Frank was riding a fine race mare and I a well-bred horse of speed and some endurance. When we reached the country around Nowata we stopped for a few days' rest and bought two extra horses (common cow ponies) to make our first run on. We left our good horses about twenty miles from Caney and the day before our venture we rode to a friend's house near Caney and spent the night…Our idea was to ride slow and arrive in town about 3 P.M. We each carried two Winchesters and two revolvers, more than our accustomed amount of arms; but we thought that in such a big venture the extra ones might come in handy. We planned to conceal our rifles about two miles from town and take a chance on doing the work with our two trusty .45 Colts.*[61]

They rode into town and tied their cow ponies about a half block away before entering the bank. When their intentions were clear, two of the bank officials ran toward the rear of the bank with Henry close behind. One ran into a back room and started to close and lock the door, but Henry jammed the muzzle of his .45 between the door and jamb so it couldn't be locked. When Henry pushed the door open, the man had grabbed a Winchester rifle but decided against trying to use it when he was confronted with two cocked .45 Colts in his face. Henry confiscated the rifle and herded the man back to the others.

Frank pulled a grain sack from his belt and began to gather up the loot while Henry covered the employees and any customers who came through

Isaac Parker was known as the "Hanging Judge." Three of the Dalton brothers were lawmen serving as deputies during his time on the bench. He also sentenced Henry Starr to be hanged. *Courtesy Fort Smith Historical Society.*

the door. When Frank returned with the sack full of paper money, Henry helped lock the ten or eleven men in a back room before making their exit from the bank. The people on the street were too scared to interfere, allowing the two robbers to make their getaway without incident, although a posse did quickly take up the chase. When they reached their stashed Winchesters,

they stopped, bent the barrel of the banker's rifle, picked up theirs and rode on, quickly evading the posse.

> Our pursuers thought we had made for the Osage hills a few miles southwest and went that way. We got to our relay mounts long before night, ate our supper and started southeast, freshly mounted. Just as the dawn appeared, we unsaddled at a friend's house ninety miles from Caney. I was not very tired, so we counted our haul before breakfast. Although the bills made a roll big enough to choke seventeen hippotami [sic], to our surprise and chagrin, it counted up to only $4,900. The foxy cashier had outmanaged [sic] us; we learned afterward that he had thrown all the bills of large denomination (amounting to $16,000.00) behind a pile of ledgers while we were taming the crowd.[62]

Henry was never arrested for this job, although it was common knowledge that he was one of the robbers. Of course, even with the ruse pulled by the cashier, this score whetted Henry's appetite for robbing more banks. After all, the $4,900 for a day's work would be over $118,113 in today's money.[63] That was big and easy money, which motivated him to organize a gang that did rob many more banks, twenty-one, which led to his statement that he had robbed more banks than anyone else.

Did Starr really rob more banks than anyone else? His stated twenty-one isn't even close to the Newton boys, who are credited with "over eighty banks and six trains."[64]

Henry Starr used a Stutz Bearcat automobile instead of horses when he attempted to rob the Harrison, Arkansas bank on February 18, 1921. While Henry was escorting the bank president into the bank vault, "the man suddenly pulled a double-barreled shotgun from a hiding place. Both barrels were discharged at the same time, effectively dispatching Mr. Starr into the somber recesses of legend. The other two men with Starr decided that it would be a good idea to head for parts unknown."[65]

Was Starr the first outlaw to use an automobile to rob a bank? Not according to an article in the February 7, 1963 issue of the *Marysville* (Kansas) *Advocate*: "Fifty years ago there was some stormy winter weather with snow piled high on Broadway in the winter and spring of 1911–12…Just before the storm struck…visitations of another character…Two banks at Waterville were robbed…One feature of the robberies was that for the first time automobiles were apparently used by the gang of thieves to make their getaway."

NOTORIOUS KANSAS BANK HEISTS

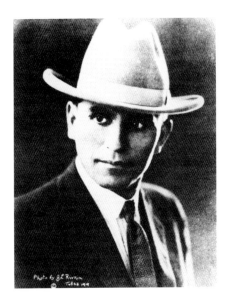

Henry Starr was a nephew of the famous Belle Starr. He claimed to have robbed more banks than anyone. *Courtesy University of Oklahoma Western History Collection, Rose Collection 2059.*

And not according to an article in the *Topeka* (Kansas) *Journal*, dated March 26, 1917, which reported that "two Kansas banks, the First National at Overbrook in Osage County, and the Kelly in Nemaha County, were wrecked and robbed by bandits early today…In both cases the bandits escaped in automobiles."

Were Henry Starr and his gang the first to successfully rob two banks at the same time? They did rob two banks at the same time on March 27, 1915, in Stroud, Oklahoma, and rode out of town with the loot. That is, they all rode out of town except Henry, who was shot by a sixteen-year-old boy and captured. The definition of successful could be challenged here because it wasn't successful for Henry, one gang member who was killed or two of the other gang members who were caught. Two others did escape with the money, but there is no indication that Henry ever received any of it.

However, it doesn't qualify for the distinction of robbing two banks at once after the Daltons failed in 1892. Turning again to the article in the *Topeka Journal* of March 26, 1917: "Two banks at Waterville were robbed simultaneously in January…the Waterville banks were the Citizens State Bank and the State Bank of Waterville. About $7,000 in loot was obtained at the latter two banks." It should be noted that although the *Topeka Journal* did call it robbery, it was actually burglary, which occurred at night as opposed to the daylight robbery at Stroud, Oklahoma.

To give Mr. Starr his due, he was obviously an extremely fascinating man.

5
THE DEADLIEST HEISTS

William Quantrill's raid on Lawrence, Kansas, on August 21, 1863, wasn't planned as a bank robbery, but the three to four hundred raiders didn't pass up the chance to loot the banks in Lawrence. "Of the three banks in town, two were robbed of every cent and the third spared only because a stubborn vault could not be blown."[66] Another account states that "every safe in town but two had been robbed."

We can account for one of the banks that was not robbed; other than that, we can only make some assumptions concerning the others. The *Lawrence City Directory for 1860–61* lists four banks: Babcock & Lykins, Lawrence Bank, Simpson Bros. and Edward D. Thompson. William H.R. Lykins of Babcock & Lykins was spared along with his home, which led him to be accused of complicity with the raiders.[67] It is possible that the Babcock & Lykins bank may have been spared.

The one bank that definitely defied the raiders was that of the Simpson Bros., whose officer wrote to Hiram Hill on August 31, 1863: "We have lost everything except the money that was in our safe…Your papers that were in our possession are all safe. The rebels could make no impression upon our safe, after a [unreadable] of hammering and pounding."[68] That safe was the only thing that resisted Quantrill that day with the exception of the city of Lawrence, which is alive and well today.

Although it may be argued that this wasn't a bank robbery, banks were robbed; therefore, it, by far, qualifies as the deadliest in the state's history.

Notorious Kansas Bank Heists

Colonel James Coffey, a fiddle-footed Indian trader, established a trading post in 1869 to trade with the Osage Indians. The first site in southeast Kansas was just one and a half miles from the Oklahoma border, which made it strategically located to trade with Indian Territory residents.[69]

Even before the town was officially incorporated, the Leavenworth, Lawrence & Galveston Railroad passed through the small settlement, which spurred its growth and industry. Although not as well known as other cattle shipping points such as Abilene, Dodge City and Ellsworth, it was a railhead for some Texas cattle during the cattle-trailing days.

The small settlement was incorporated in 1873 and therefore was a latecomer to the Kansas frontier but managed to experience all the virtue and vice, success and failure, as well as fame and infamy to hold its own with most nineteenth-century Kansas communities. However, Colonel Coffey never dreamed that his little trading post would become famous for an attempted bank robbery since there wasn't a bank in the town until he was long gone. Eventually, a clay works, a glass manufacturing company and agricultural pursuits rounded out the commerce, along with the standard

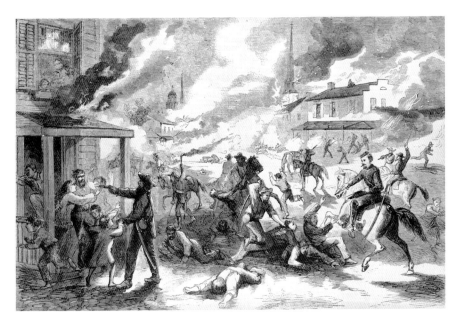

A *Harper's Weekly* illustration of William Quantrill's 1863 raid on Lawrence, Kansas.

hardware stores, mercantile establishments, livery stables, banks and residential homes.

It was to this southeast community that the Dalton family arrived about 1860.[70] Father James Lewis Dalton was born in Kentucky and moved to Jackson County, Missouri, where he married Adeline Lee Younger on March 12, 1851.[71] Adeline Younger was an aunt of Cole Younger and the other Younger brothers of the James-Younger outlaw gang. Lewis, as he was called, was a farmer and raised horses for trade and racing. His one fault was gambling.[72]

Adeline lived to bury nine of fifteen children, and four of them died violent deaths. Those four were Frank, Grat, Bob and Bill.

Of the fifteen children, it was Grat, Bob, Bill and Emmett who strayed from the peaceable, if not always successful, pursuits of the family. Grat, Bob and Emmett were the principal players in the glorified Dalton gang. Considering all the press they received, they weren't especially good at the outlaw trade and only achieved fame through failure.

Their path to crime and then to Coffeyville started as many other outlaws of the era—by working both sides of the law. Frank Dalton, born in 1859, was the sixth son of Lewis and Adeline, followed next by his brother Grat, who was born in 1861. Then there were two siblings born before Bob Dalton arrived in 1869, followed by Emmett in 1871.

There are plenty of "facts" published about the Daltons, but sorting out the ones that are actually true is a daunting task. Of all the research on the Dalton gang, the source that appears to rely most heavily on official documents is Nancy B. Samuelson's *The Dalton Gang Story: Lawmen to Outlaws*. Her research places the dates for the Dalton boys' service to the law beginning sometime after 1887, which was the year Frank was killed in the line of duty.

Frank Dalton was the first of the brothers to ride for Judge Parker of Fort Smith, Arkansas. The "Hanging Judge" and his deputies were the law for seventy-four thousand square miles that included some of the roughest terrain and toughest outlaws in the nation. After Frank's death, Grat became a deputy for the Western Arkansas District, and Bob also served as a deputy in that district.[73]

Marshal R.L. Walker of the Kansas District said:

> *Bob and Emmett were deputies under Col. Jones (Walker's predecessor) and that he retained them for a few months, but removed them in the fall of 1889.*
>
> *Records, primarily in the Kansas City branch of the National Archives, show the following: (1) Grat and Bob were sworn in as deputies in the District*

of Kansas on 10 January 1889. (2) In 1889 Bob was employed as a detective by the Osage Indian Agency from April through September of 1889 (records past that date have not been found). (3) Several documents, subpoenas, warrants, etc., for the Kansas District show Robert Dalton as a deputy in that district throughout the months of March through September 1889. Bob was serving under two different U.S. Marshals during this time, W.C. Jones and R.L. Walker. (4) One document, dated in August 1889 has been found for Grat Dalton as a deputy in the District of Kansas. This was a warrant of arrest served by Grat on John Poor for stealing a gun. (5) Emmett Dalton's name is found on two documents dated June 1889 for the District of Kansas. One is a receipt of pay for guarding prisoners. The other a complaint sworn by Emmett against two men for introducing and selling whiskey in the I.T. (6) On 16 June 1890 a J.C. Johnston made out a power of attorney to George Purcell for Purcell to "ask, demand and receive from the United States the sum of twenty dollars that Johnson was owed guarding prisoners for deputy marshals Robert Dalton and Henry Roberts of the District of Kansas."[74]

These documents indicate that the Daltons were still operating on the lawful side of the law up until sometime before June 1890. That sometime was probably December 25, 1889, when "one Henry Roberts, another deputy, filed a complaint against Robert and Emmett Dalton, Harry Callahan, and Jasper Riddle for Introducing intoxicating liquor into the Osage Nation on 25 December 1889. A warrant for the arrest of the four men was issued."

Robert and Emmett were arrested on March 21, 1890. Charges were dropped against Emmett, but Robert was held to appear at the next regular term of the district court at Wichita, on September 1, 1890.[75]

If this marked their shift to the other side of the law, it would make their outlaw career span just over two years: March 1890 to October 1892.

During that time, they supposedly robbed trains, rustled cattle and stole horses, in addition to robbing trains in California. There is little evidence to support most of these claims. This is a pattern that is true for many outlaws. Once their names begin to appear in the press, they are often credited with any holdup, robbery or murder that the law can't immediately solve.

The evolution of the Dalton gang began with Bob Dalton, who was recognized as the leader. Exactly how many different men joined the gang and what part they played in any of the gang's exploits is uncertain. However, according to Emmett, the gang "consisted of Bob, Emmett, Grat, George Newcomb, Charley Bryant, Bill Power, Charley Pierce, Dick Broadwell, William McElhanie and Bill Doolin."[76]

The gang members who attempted to rob the two Coffeyville banks are absolutely identified as Bob Dalton, Grat Dalton, Emmett Dalton, Bill Power and Dick Broadwell. That these five men rode into Coffeyville on the morning of October 5, 1892, is an established fact. However, some writers believe there was a sixth man who rode with them as they approached the town but was prevented from accompanying the others when his horse went lame. The identity of the sixth man, if he did exist, is an object of much conjecture.

Putting that issue aside, the five outlaws entered Coffeyville from the west.

> *The road over which the horsemen were passing becomes Eighth Street after it enters the city. They continued right along on this thoroughfare until they reached Maple Street, which crosses Eighth at the Episcopal Church...They were now within one block of the business portion of the city. A number of the residents on both sides of Eighth Street observed them as they passed, but no one was particularly attracted to them at the time...The party never paused, but wheeled into Maple Street...and rode south. Passing the Long-Bell Lumber Company's office, they suddenly diverged into the alley that runs east and west through the block, from Walnut Street to Maple, and halting...dismounted and hitched their horses to the fence...the men walked at an ordinary pace down the alley, in an easterly direction towards the Plaza.*[77]

This ride through the streets and alleys of a town where many of the residents knew the Daltons was either daring or wishful thinking. Even though three members of the gang tried to disguise their identities, it was inevitable that someone would recognize the Dalton boys, and by this date, they were known outlaws.

Grat Dalton, Bill Power and Dick Broadwell entered the Condon & Co. Bank by the southwest double doors. Bob Dalton and Emmett went on past the Condon Bank and entered the First National Bank just across the street to the east. They had now passed the point of no return, led there by the grandiose idea of besting the James gang's idea of robbing two banks at the same time.

Simultaneous with the gang's entrance into the banks, the cry of "the bank is being robbed" passed quickly up and down the streets. Immediately, citizens began to arm themselves from the stock of guns and ammunition at the two hardware stores in the plaza area. "The hardware stores, where guns and ammunition are kept for sale, quite naturally became the rallying points for the alarmed citizens. The store of Isham Brothers & Mansur, hardware

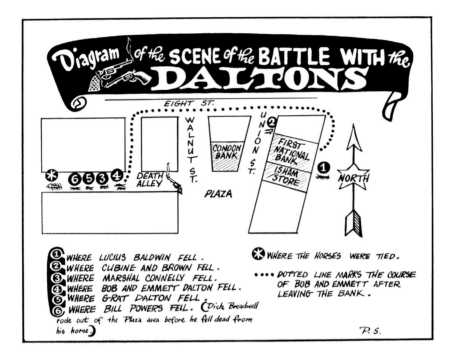

A diagram showing the relationship between the two banks and the alley where the horses were tied. *Courtesy Coffeyville Historical Society.*

merchants is a large one-story brick building…It is situated on the east side of Union Street, immediately opposite the bank of C.M. Condon & Co., and adjoins the First National Bank on the north…The store of A.P. Boswell & Co., hardware merchants, is a large two-story brick, with basement… The proprietors of these stores most willingly passed out their guns and ammunition to the eager citizens."[78]

It is interesting to note that there wasn't a single armed man in the area, including the city marshal, at the time the robbery began. All of the firearms used against the gang were furnished by the merchants with the exception of one Winchester rifle.

Inside the Condon & Co. Bank, Grat Dalton, Bill Power and Dick Broadwell were in trouble from the very beginning due to the fact that the large plate-glass windows allowed outsiders to observe the robbery in progress. And it gave the armed citizens a target to shoot at.

Grat, in charge of robbing the Condon Bank, was easily fooled by cashier C.M. Ball, who told Grat that the burglar-proof chest in the vault was on a

The Condon & Co. Bank building as it appears today. *Photo by author.*

timer and couldn't be opened for another ten minutes. Grat stated that they could wait and then asked where the gold was. Ball said they didn't have any. Grat gave Ball a two-bushel grain sack and ordered one of the bank proprietors, C.T. Carpenter, to put all the money into the sack. Carpenter complied, and when Grat asked how much cash they showed on the books, he was told $4,000: $3,000 in silver and $1,000 in currency.

Here is another indicator of how little, if any, planning or knowledge of banking practices was known to the Dalton gang. Three thousand silver dollars weigh in at just over 175 pounds. Grat had the money in the grain sack, but it took two men, Ball and Carpenter, to carry the sack to the front door. By this time, the armed citizens were firing Winchester and shotgun rounds through the plate-glass windows at a terrific rate.

Slowly but surely, it became clear to Grat that they couldn't manage the bag of silver and fight at the same time, so he had Ball dump the contents of the bag on the floor and sort out the currency, which Grat grabbed, and then the three outlaws exited the bank through the same door they

Right: The entrance to the vault in the Condon Bank. The cashier made Grat Dalton believe the safe was on a time lock and couldn't be opened for a few minutes. In fact, it was open, with $20,000 inside. *Photo by author.*

Below: Bank employees were forced to put the money from the Condon Bank into this grain sack. The $3,000 of silver dollars would have weighed about 175 pounds. *Courtesy Coffeyville Historical Society.*

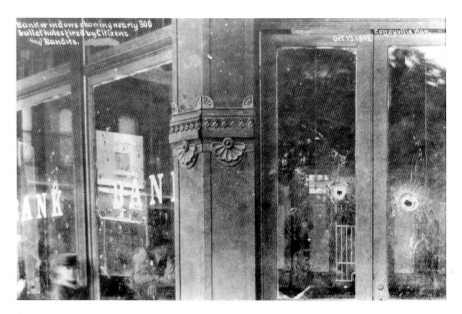

There were approximately eight bullets that hit the front of the Condon Bank during the robbery attempt. The glass company that installed the windows used the image to advertise their shatterproof glass. *Courtesy Coffeyville Historical Society.*

had entered and made a running fight for their horses tied in the alley. Miraculously, no bank employees or citizens inside the bank had been hit by the barrage of gunfire.

Across the street in the First National Bank, Bob and Emmett took control of the bank employees and customers while instructing the bookkeeper, B.S. Ayers, to put all the money from the cash drawers in a sack. Then Bob ordered him to bring out all the money from the safe. Ayers said he didn't know the combination. Bob told him to get it, which he did, and dropped some money in the sack. Bob asked if that was all, and Ayers answered that there was some gold in the vault that Bob told him to get and put in the sack.

Bob again asked if that was all. Ayers pushed the safe door closed and said that was all, but Bob went to the safe, opened the door and found two packages of currency containing $5,000 each. Bob emptied all the silver from the safe onto the floor, thus avoiding the mistake that Grat had made. At this point, the employees were ordered to move to the front door, followed by Bob and Emmett. Once the employees were out the door, Bob and Emmett started to follow but were fired on by George Cubine with a Winchester and C.S. Cox with a handgun. The Daltons retreated back into the bank followed by B.S. Ayres and W.H. Shepard.

Bob went to the front door and fired before ordering Ayers and Shepard to lead them to the rear of the building, where they exited into the alley. Neither citizens nor outlaws had been seriously wounded up until this time, but that all changed in the following few minutes.

At this point, all members of the Dalton gang were on the streets engaged in a life-and-death gun battle with dozens of armed Coffeyville citizens. There was obviously no escape plan nor a backup plan if things went bad. Now it was just every man for himself in a desperate bid to reach the horses and get out of town alive.

Without going into a second-by-second account of the battle, the end result was four dead members of the Dalton gang: Bob Dalton, Grat Dalton, Bill Power and Dick Broadwell. John Kloehr, a livery stable owner, is thought to have killed Dick Broadwell, Bob Dalton and Grat Dalton, although they all suffered more than one gun shot, so it is impossible to know for sure.

Emmett Dalton was seriously wounded, having suffered twenty-three bullet wounds, and wasn't expected to live. However, there were many in Coffeyville who wanted to hang him anyway. Emmett had received the majority of his wounds trying to help his brother Bob, who was fatally

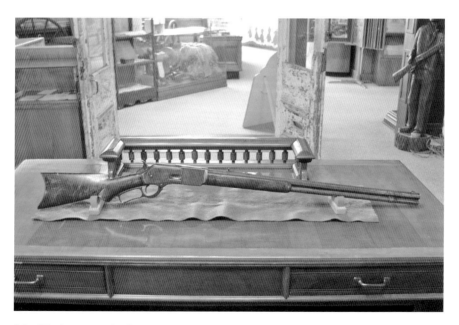

John Kloehr operated a livery stable in Coffeyville at the time of the Dalton raid. When the call to arms came, he used this 1873 Winchester rifle to good effect. *Courtesy Coffeyville Historical Society.*

The mural in the Dalton Defenders Museum honors the four men who died defending their town. *Left to right*: C.T. Connelly, Geo. B. Cubine, L.M. Baldwin and Charles Brown. *Courtesy Coffeyville Historical Society.*

wounded before he could reach the horses tied in the alley. Dick Broadwell managed to reach his horse and race out of town but fell from his horse and died of his wounds a short distance outside Coffeyville.

Four citizens of Coffeyville gave their lives to defend their town: city marshal C.T. Connelly, along with three citizens—Lucius Baldwin, George Cubine and Charles Brown. Bob Dalton is believed to have killed George Cubine, Charles Brown and Lucius Baldwin. Grat Dalton is said to have shot Marshal Connelly in the back, killing him instantly.

At this point, all that remained was the burying of the dead, the treating of wounded men and the trial of Emmett Dalton, who somehow survived his wounds. Emmett was sentenced to life at Lansing.[79] He was pardoned in 1907 after serving fourteen years. He never returned to crime but instead got married and was successful as a building contractor and real estate developer in California. Authors writing about the Dalton gang are not in agreement on his activities after his parole, but it is generally agreed that he never returned to criminal activities.

A fitting epilogue for the Dalton gang would be "they didn't plan to fail, but failed to plan." The attempted robbery of the two Coffeyville banks must be noted as one of the worst bungled bank robbery attempts in the history of the old West. It cost the lives of four outlaws and four

Notorious Kansas Bank Heists

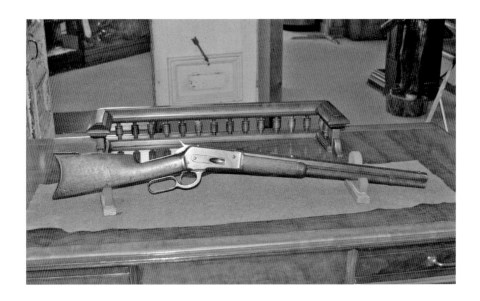

These are 2 of the slugs removed from Emmett Dalton after the raid by Dr. W.H. Wells, pioneer Coffeyville physician. Emmett was struck 23 times & experienced physical discomfort, as a result of his wounds, for the rest of his life. Dr. Wells' surgical instruments are also displayed in this case, and a letter he received from Emmett is on the wall to the left.
 Displayed by Howard W. Wells, Kokomo, Ind.

23 slugs were removed from the body of nearly dead Emmett Dalton by pioneer surgeon Dr. W.H. Wells, who used this kit of surgical instruments on the wounded bandit. Emmett served time in the Kansas State Penitentiary, was pardoned, and finally died in bed. The only one of the gang to survive the raid except for a possible sixth "Mystery Man." There is considerable evidence that a sixth man, galloped west out 8th street when the shooting began. On the wall in this room is a letter written in later years by Emmett to Dr. Wells.
 Displayed by Howard W. Wells, Kokomo, Ind.

Gunslingers to Gangsters

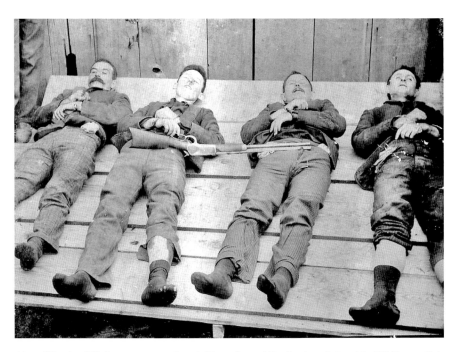

Above: The dead Dalton gang members laid out for public viewing. *Left to right*: Bill Power, Bob Dalton, Grat Dalton and Dick Broadwell. Souvenir hunters turned their pockets inside out, removed their boots and cut off some of their trouser legs. *Courtesy Coffeyville Historical Society.*

Opposite, top: Bob Dalton carried this Winchester rifle in the Coffeyville raid. It was probably Bob who killed Lucius Baldwin, George Cubine and Charles Brown. *Courtesy Coffeyville Historical Society.*

Opposite, middle: These are two of the twenty-three hunks of lead that struck Emmett during the running gunfight. The bullets were removed by Coffeyville physician Dr. Walter H. Wells. *Courtesy Coffeyville Historical Society.*

Opposite, bottom: After Emmett Dalton was released from prison, he placed the headstone on this grave. The first grave marker was only the pipe rail to which the robbers tied their horses before the robbery. *Photo by author.*

Coffeyville citizens. There was also one outlaw, Emmett Dalton, who was wounded, as well as some Coffeyville citizens. A heavy price to pay for a few thousand dollars.

Author Robert Barr Smith summed up his research on the Dalton gang story:

> *Along the way I may well have quoted the wrong people, drawn the wrong conclusions, and chosen the wrong accounts of the raid on which to rely. It's*

Notorious Kansas Bank Heists

easy to take a false trail when you write about the bad old outlaw days, for the tall tales are many and the truth is forever elusive.

The best advice I can give readers is to doubt everything about the Dalton mythology...and to enjoy it all.[80]

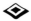

In the death house of Colorado's state penitentiary in Canon City on July 11, 1930, at 9:01 p.m., Ralph Fleagle, hangman's noose around his neck, stood before the gallows' iron trapdoor just one step away from eternity.[81]

Fleagle's journey to the hangman's noose began in Lamar, Colorado, where bank president Amos Parrish died in a shootout with the Fleagle gang. Parrish tried to defend his bank armed with a Colt .45 given to him by the outlaw Frank James.

The robbery occurred on "Wednesday, May 23, 1928, when four men entered the First National Bank of Lamar at 1:10 p.m." After shooting the bank president and his son, John, the four robbers sped out of town with two hostages and $219,000 in cash and bonds.[82]

Parrish's actions were admirable, if somewhat foolish. His longtime friend G.J. Creaghe warned against resistance in case of a holdup, but the bank president nevertheless was confident that with his early training in the use of firearms and his nerve he would be able to thwart the intentions of robbers.

"I told him repeatedly that no amount of money was worth the risk he'd take in trying to defend his possessions. Bank robbers are prepared to kill and they won't be bluffed."[83]

Maybe Parrish was influenced by the history of the single-action Colt .45 that he kept in his desk drawer. He might have thought, "Surely Frank James wouldn't have given up without a fight." The story of how that Colt ended up in Amos Parrish's desk drawer is noteworthy. According to

John Parrish, son of Amos Parrish, was also killed by the Fleagle gang during the Lamar robbery. *Courtesy Finney County Historical Society.*

a notarized statement by John Alexander dated April 25, 1979, the .45 Colt single-action revolver

> *was given to Amos Newton (Newt) Parrish by Frank James sometime in the 1880s, at which time Parrish was ranching in the Wet Mountain area West of Pueblo, Colorado. A few years later, Parrish moved to Lamar where he was associated with the original First National Bank, being President of the Bank for many years. Parrish kept this gun in a drawer of his desk in the bank and on occasion would exhibit it and tell of how he acquired it.*

Seventy-seven-year-old bank president Amos Parrish was killed in a gunfight with the Fleagle gang during a bank robbery in Lamar, Colorado. *Courtesy Big Timbers Museum.*

The above statement was executed in Murfreesboro, Tennessee. The document is now held at the Big Timbers Museum in Lamar, Colorado. In a letter also dated April 25, 1979, John Alexander added details of how the gun was acquired by Newt Parrish.

> *To the best of my recollection, Newt Parrish's story of how he recieved [sic] the gun went something like this:—One evening a lone rider rode into his ranch headquarters (in the Wet Mountain area)—stayed the night and when leaving the next, offered to pay for the services to himself and his horse. This of course was refused as such procedure was unthought of in those days. Some weeks later, the same rider again rode in and stayed the night and again offered payment for the care recieved [sic]—and again was refused. Some time later, a second rider showed up carrying this gun, wrapped in a cloth and presented it to Parrish. This rider identified the first man as being Frank James sho [sic] had sent the second man to deliver it to Parrish for services rendered. He stated that James wanted Parrish to accept the gun as from a friend and considered Parrish to be "An honest man and a true friend."*[104]

Amos, or Newt as he was called, always referred to the Colt as "Ol' Betsy." If, as the letter states, it was Frank James's gun, then this time it was used to defend a bank rather than rob one.

Fleagle gang member Howard "Heavy" Royston after his capture. *Courtesy Finney County Historical Society.*

The Colt single-action .45 was given to Parrish in the 1880s, which means the cartridges had been in the gun at least forty years, which is perhaps why it misfired when Parrish tried to shoot the robber a second time.

Gang member Howard Royston was shot in the jaw by Parrish, but he didn't go down and managed to stay on his feet during the rest of the robbery. He was six feet four and weighed 240 pounds, which is probably why he was called "Heavy Royston." He served in the military during World War I and was decorated three times for bravery.

The gang's blue 1927 Buick Master Six was a favorite getaway vehicle for the Fleagles because it was big and it was fast. After leaving the bank, the big Buick headed north across the Arkansas River bridge and then turned west on U.S. Highway 50. "About two miles west of Lamar the bandits turned north on county road, (County Road 8), and after a short drive stopped and shoved Eskel Lundgren out saying, 'Let's get rid of the one-armed bastard. We don't need any damn cripple. We'll keep the other one.'"[85] The other one referred to was hostage Everett A. Kesinger, who was the second employee they forced into the getaway car.

Prowers County sheriff Lloyd E. Alderman arrived at the bank just minutes after the gang fled. Harry Anderson was a customer in the bank during the robbery who came out and jumped into the sheriff's Studebaker Commander, and they started after the Buick. The Studebaker proved faster than the Buick and gained on the Buick even though the sheriff stopped a couple times to inform people along the route what had happened and to call Lamar and notify the authorities which direction the chase was headed.

The bandits crossed Sand Creek and stopped just on the opposite side. Wisely, Sheriff Alderman also stopped about 280 yards from the Buick where a couple of the gang members were standing and watching the sheriff. "When I saw the rifle barrels I told Anderson they were going to riddle our car so we had better get in the gutters. They fired about 25 shots at us with

This 1927 Buick is the same model as the auto the Fleagle gang used for a getaway during their robbery of the First National Bank in Lamar. *Courtesy Big Timbers Museum. Photo by author.*

high-powered rifles, getting nine hits into my car and succeeded in partially disabling it. Then they got back into their car and drove away from us as I only had two gears to go with," Alderman said.[86]

A historic search was launched for the robbers, who seem to have vanished without a trace except for two dead bodies they left behind. One victim was Dr. William Wineinger of Dighton, Kansas, who had been conned into going with a couple of the gang members to treat the injured Royston. After he treated Royston, they took the doctor to a remote location north of Scott City and shot him in the back of the head and pushed him and his car into a ravine. The car was spotted from a search plane that had been brought into the search from the Colorado National Guard out of Denver.

It is estimated that five hundred citizens in automobiles and airplanes searched for the gang in Colorado and Kansas but failed to identify or locate the robbers, who were now wanted for three murders. It wasn't long before the murder count went to four with the discovery of Everett Kesinger's body in an abandoned shack near Liberal, Kansas. He, like Dr. Wineinger, had been shot in the back of the head execution style.

Ralph Fleagle and his brother Jake were the founding members of this gang of outlaws who, along with Royston and a fourth member, George

Laurie Oshel of the Finney County Historical Society with a window taken from Dr. Wineinger's car. She is pointing to the area where Jake Fleagle's fingerprint was found. *Courtesy Laurie Oshel.*

Garden City, Kansas police fingerprint examiner R.S. Terwilliger is credited with discovering Jake Fleagle's single fingerprint on Dr. Wineinger's car window. *Courtesy Finney County Historical Society.*

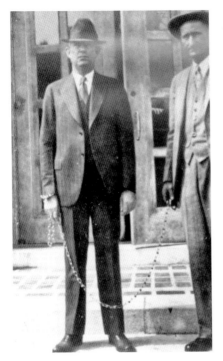

Sheriff Alderman with captured Fleagle gang member Ralph Fleagle. *Courtesy Big Timbers Museum.*

Abshier, robbed banks in Kansas, Colorado, Oregon and California. Robberies in these states can be documented, and they probably robbed banks in other states as well. A California researcher believes that the Fleagles were responsible for 70 percent of the state's bank robberies during the Fleagle era.

They didn't neglect Kansas and successfully robbed several banks in the state during their career, and Sheriff Alderman said that "the gang had taken more than a million dollars over a ten to twelve year period.[87]

The Fleagle gang, dubbed the Kansas Wolf Pack by the press, eluded law enforcement for at least ten years, accumulated a take of over $1 million, built an expensive home and drove new automobiles. Gang member Ralph Fleagle left an estate of $100,000 when he was hanged in 1929.

The father, Jacob, and mother, Anna, came to western Kansas from Louisa County, Iowa, and homesteaded on a quarter section of land near Garden City, Kansas. Jake Fleagle Sr., also called Old Jake, sired a family of four sons and one daughter. The sons were Ralph, Fred, Walter and "Little Jake," and the daughter was named Florence.

As unlikely as it may seem, the headquarters for the Fleagle gang was on a farm just a few miles from Garden City, Kansas, where their neighbors considered the family's behavior somewhat reclusive and a bit odd.

Neighbors also had trouble equating the Fleagle family's lifestyle with the lack of any serious farming and ranching on the property, which naturally led to speculation that the Fleagles were involved in illegal activities.

> *In the 1920s the neighbors began to notice that Ralph and Jake Fleagle were constantly coming and going to the farm and that the family began to prosper quite noticeably. There was a new house, a tractor and many more*

cattle. The brothers told their family that they had done well in the stock market. However, what they were doing was robbing. They were in a gang that went up and down the Sacramento Valley of California, raiding big-money crap games and high-stakes gambling houses. Historians estimate that the Fleagle brothers and their gangs were responsible for 60 percent of the heists in and around Kansas and California during the 1920s.[88]

Some residents of the community suggested that the entire Fleagle family was involved: "Old Jake and a fourth son, Walter, also participated in the family bank robbing business. Under different names, they had post office boxes in Garden City and Dodge City, and also under assumed names they had sizeable bank deposits in Dodge City, Garden City and Scott City banks."[89]

"Fred Fleagle leased a farm in May of 1927, a few miles south of Marienthal, near Leoti, Kansas in Wichita County. A granary was rigged up with a side door raised by pulleys so an automobile could be driven into the building."[90] Apparently, one story they told to explain their prosperity was that they were engaged in buying and selling cattle and horses. Fred's farm later became known as the "Horseless Horse Ranch" because few livestock were seen on the premises.

And to add fuel to their suspicions, there were rumors that some of the Fleagle neighbors would see flickering lights in the field during the night and believed it was the Fleagles burying their stolen money. Some credit was given to this story when Old Man Fleagle asked a neighbor, a Mr. Crist, to help him with a chore. Of course, in a farming community, a request for help was not turned down. Crist accompanied Fleagle back to the Fleagle farm, where the old man stepped off so many paces this way and so many paces another direction and then told Mr. Crist to dig. This was done a second time, and at both locations, bags of money were uncovered when the neighbor had dug deep enough. Fleagle gave Crist the paper money to pay for his help, but Fleagle kept the silver.

Another story has the Fleagle brothers waking a neighbor during the middle of the night and asking to borrow some gasoline because they'd run out. When the neighbor began pouring gasoline into the tank it began running out through a couple of bullet holes in the gas tank. The Fleagles offered to pay for the gas, which the neighbor declined, saying that he was glad to help a neighbor—it was the thing to do.

The search for the Lamar bank robbers turned murderers went on for months before Ralph Fleagle was arrested in Kankakee, Illinois, on July

Captured Fleagle gang member George Abshier. *Courtesy Finney County Historical Society.*

26, 1929, at a bank where he was cashing a check using the name of Art Coons.[91] In prison, Fleagle gave authorities information that led to the arrest of Howard Royston on August 16, 1929, in San Andreas, California. George Abshier was arrested in Grand Junction, Colorado, on August 15, 1929.

Royston and Abshier were transferred to Lamar, where they were sentenced to death, but Ralph, because of the deal he made to finger Royston and Abshier, was given life in prison. Ralph stubbornly refused to divulge any information about his brother Jake, who was still at large.

Colorado authorities decided that Ralph, despite the deal they made, had to die along with Royston and Abshier. This turn of events is what brought Ralph Fleagle to the Colorado penitentiary, where at 9:03 p.m. on July 11, 1930, he took the final step onto the trapdoor that activated the do-it-yourself hanging machine used by the penitentiary.

The do-it-yourself, or self-hanging, gallows was invented by an inmate with the idea that it alleviated the need for a hangman if nobody agreed to be the executioner. It consisted of a couple pulleys overhead that the rope passed through with the hangman's noose on one end and a heavy weight, sometimes of three hundred pounds, on the other. A metal plate was set in the floor of the gallows, and when the noose was correctly placed around the subject's neck, all that was required was one step onto the plate and it would release the weight, which would drop and jerk the person upward and, hopefully, snap his neck, killing him instantly. It didn't always work that way, and some strangled to death after long minutes.

Abshier and Royston both took the final step onto the trapdoor on July 18, 1930, at 9:40 p.m. and 10:37 p.m., respectively. Abshier was buried in the prison graveyard called Woodpecker Hill. Royston's body was shipped to Richmond, California, where it was received by his wife and mother.

Jake Fleagle was now the only gang member still free, so the search was intensified to either capture or kill Little Jake, who had seemingly just vanished. Where he had gone into hiding seemed to have been a very unlikely place, except for his rural background.

Jake had been residing more or less openly, for about eight months, in the tiny state-line community of Ridgedale, Missouri, under the name of Walter Cook.

> *The "Cook brothers" were peaceful, roughly clad chicken farmers living quietly in an oak-shaded white cottage beside Highway 65, a mile or so north of the Missouri-Arkansas border. The matter of greatest concern to them, apparently, was setting of eggs for their white leghorn hens…Walter, it was understood, was suffering from lung trouble and had to rest. He sunned himself on the porch of the cottage, fed and watered the chickens, and walked in the deep forested canyon which ran along the back of the house under a protecting ridge. There were no close neighbors and there was little to disturb his "rest cure." Members of the highway crew who were building the new route past the place did call at the house frequently… Walter always had his .45 Colt on him and at one point drew it from his shirt, then put it back and grinned…Once a visitor discovered a machine gun in the Cook home. "Where'd y' get that, Walter?" he inquired curiously, inspecting the weapon.*
>
> *"Got it when I was in the World War," Cook explained casually. "It's just a keepsake."*[92]

Law enforcement's pursuit was relentless as they followed every lead that came in from any of the state and federal agencies, including U.S. postal inspectors. As it turned out, it was Jake's handwriting, or the letter "D," that led "five police officers, two from Kansas City, two from Los Angeles and one from Colorado Springs, and also three postal inspectors" to be waiting for Jake to board a train at Branson, Missouri.

"Samples of Fleagle's handwriting, obtained from the Fleagle ranch, had revealed that the outlaw used a distinctive letter D. and when on July 30, 1930, Governor Adams of Colorado received a letter pleading for clemency for Ralph Fleagle, authorities quickly spotted the telltale D in the 'Dear Sir:' of the letter."[93]

That letter "D" was all it took for lawmen to be on that train at Branson as Jake, aka Walter, prepared to board the train.

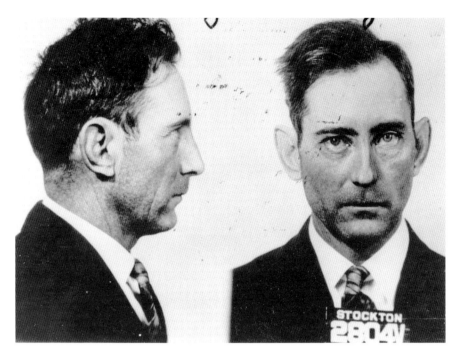

Mug shot of Jake Fleagle. *Courtesy Finney County Historical Society.*

> *The officers moved toward the passenger car entrance. As Jake came into the vestibule and was about to take the first seat, facing back through the car, they approached and ordered him to "Put 'em up," but Fleagle reached for his gun. One report says that he had his finger on the trigger. One of the officers fired into his stomach. Fleagle's gun hand was grabbed by another officer, and though he was said to have struggled fiercely, he was soon handcuffed and put in leg irons. The lone bullet had emerged from Fleagle's back and was later found embedded in the sill of the coach window… Before he lapsed into unconsciousness, the wounded man admitted he was Jake Fleagle, but answers to other questions were evasive.*[94]

Jake was taken to the Baptist Hospital in Springfield, Missouri, where doctors operated in hopes of saving his life, but the bullet had done considerable damage and abdominal hemorrhaging developed.

> *Before he became irrational Fleagle called Dr. Guy B. Mitchell who had treated his wounds to his bedside and thanked the physician for his care.*
> *"Anything you want to tell me, Jake?" Dr. Mitchell asked.*

"No, nothing, except I wish mother would hurry," Jake answered. "I guess I robbed my last bank. I'm going to die, doctor. I've done my last job."[95]

He died on Wednesday, October 15, 1930, without revealing any additional information about his criminal career. It was reported that in his last hours he kept calling out for his mother.

There is a story told by the locals in and around Garden City saying that when Jake's body was returned to Garden City for burial Mrs. Fleagle went to the cemetery and told the grave digger that she didn't know why he was digging a grave in the Fleagle plot because it wasn't Jake that was killed in Branson. And there are some today who compare the picture of Jake with a picture of the man killed in Branson and conclude that Mrs. Fleagle just may have been correct.

There is also a story that Jake's wrists were slit and he committed suicide to defy the system of the satisfaction of hanging him. Or since the bullet wound didn't appear to be fatal, perhaps someone didn't want to give him a chance to live and the possibility of escaping from incarceration.

Today, the Fleagle gang has slipped into obscurity with few Kansans aware they ever existed. The Fleagles made headline copy across the nation after their robbery of the Lamar, Colorado bank. The hunt for the gang established some milestones in criminal investigations. The resulting search was the first time law enforcement used airplanes to search for criminals in the states of Colorado and Kansas. It was also the first case in which an arrested suspect was transported by airplane.

The Fleagle family cemetery plot in Garden City, Kansas. *Photo by author.*

Left: Frenchman Alphonse Bertillon devised a system to identify criminals based on physical body measurements. His method was flawed and soon replaced by fingerprints. *Frontispiece from Alphonse Bertillon's* Identification Anthropometriue *(1863)*.

Below: When this photo was taken in 1924, J. Edgar Hoover was only twenty-nine years old. He was head of the Bureau of Investigation within the Justice Department. *Courtesy Library of Congress.*

Artist's enhancement of the single fingerprint lifted from Dr. Wineinger's car window. The print was sent to law enforcement agencies throughout the United States. *Illustration by Chuck Beemer.*

And it has been credited by the Federal Bureau of Investigation as the first robbery solved through the use of a "single fingerprint."

At the time of the robbery there was no Federal Bureau of Investigation, but rather the Department of Justice's Central Bureau of Identification. The newly appointed head of the department was J. Edgar Hoover, who used the next few years to bring the FBI as we now know it into existence in 1932.[96]

Two syndicated cartoonists used the Fleagle gang as the inspiration for characters in their cartoon strips. Evil Eye Fleegle, created by cartoonist Al Capp, became a regular in the *Li'l Abner* cartoon strip and was also part of the cast in the Broadway musical based on *Li'l Abner*. And cartoonist Carl Barks created the Beagle Boys, who became characters in the *Donald Duck* cartoon strip.

Four criminals and four citizens lost their lives as a result of the Lamar bank robbery. Again, a heavy price to pay for trying to protect money that was probably covered by insurance.

6
FIGHTING BACK

Citizens, Bankers and Vigilantes

Bank robberies reached such regularity in the plains states that they threatened to sink the entire banking system unless some measures were taken to stem the tide. The insurance rates for robbery coverage were approaching the prohibitive threshold in many plains states, including Kansas, which led in losses during some years.

While banks in eastern states were paying approximately one dollar per thousand dollars of a bank's holdings, Kansas banks were paying approximately twenty dollars for the same coverage. But even at that, the premiums didn't cover the losses, prompting the Kansas Bankers' Association to inform its members:

> Let it be known that Kansas burglary and hold-up losses for the year 1919 cost the Ocean Accident and Guarantee Corporation alone 137.6 per cent of earned premiums…the state representative of one company which carries the insurance of some twenty-five or thirty banks in Kansas has recently stated that the one or two heavy losses which they were called upon to pay would amount to 1300 per cent of the earned premiums and relatively so with other companies.[97]

This was unsustainable for the insurance companies, making it imperative that something be done to counter the rash of bank robberies.

Following is an article published in *Bankers Magazine* in July 1919 under the headline "Burglary Preventatives" and reprinted from the original

authored by Secretary W.C. Macfadden of the North Dakota Bankers Association:

> *We have occasionally called attention to a few very important things that can be done in every bank to either prevent robbery and hold-ups or assist very materially in apprehending burglars or hold-up men, and again call the attention of members of the Association to former suggestions.*
>
> *Every bank in the smaller places where there is no police protection should be the owner of two or three Winchester riot guns loaded with buckshot shell. This gun is a cylinder bore, quick fire. It is almost sure to kill or disable a man at one hundred yards. Further, the gun is good for hunting. The bank should also own a Winchester repeating rifle, 38* [sic] *calibre, which should be kept in the bank for daylight use. This rifle will kill or disable a man at three hundred yards, and eleven shots can be fired without reloading. The riot guns should be left in the homes of persons living near the bank who will volunteeer* [sic] *to render assistance in case of a night attack.*
>
> *A screw driver with candles and matches should be in every bank vault so that in case you are locked in by hold-up men, the codbination* [sic] *can be quickly taken off and the vault opened.*
>
> *A quart of full-strength amonia* [sic] *and quart of formaldehyde, where it is practicable, should be kept between the inner and outer doors of the vault, or in the safe, especially if it is one of the old-style square door safes. The bursting of these bottles creates a gas that will very much retard or stop entirely the work of the robbers.*
>
> *Every bank has more or less currency, usually in large bills, which remains in the safe permanently as a part of the reserve funds. Two or three packages of such currency should be kept on hand permanently, and the numbers and description of the bills should be carefully preserved. If the currency is new the bills will be numbered consecutively so that if the first number is kept in mind the balance of the numbers will be easily remembered. This is a very simple precaution and may be of great value in locating stolen money.*
>
> *Banks should also see to it that telegraph and telephone companies in every town keep on hand a supply of wire so that in case of burglary, if the wires are cut, which is usually the case, they can be easily and quickly repaired.*[98]

Did bankers heed this advice about obtaining firearms? Some of them did, which is confirmed by an Associated Press release on June 5, 2015, that

reported, "A southeast Kansas sheriff is considering whether to sell a piece of history to help fund other needs, or keep it for its nostalgic value."

What is this piece of history? "Bourbon County Sheriff Bill Martin has been researching options for the Thompson submachine gun the Kansas governor issued to the county in 1933 as a way to defend against well-armed gangsters."

But arming banks and citizens began years before 1933, as evidenced by the forming of vigilante groups that were furnished firearms by the bankers' associations in cooperation with the state government.

The great buffalo-hide harvest began in western Kansas in the late 1860s, and as the herd was killed off in Kansas, the remainder of what is referred to as the southern herd was pushed south into Texas. After 1874, there weren't enough of the big shaggies left in Texas to make it profitable for the professional hunters, so they went north to decimate the northern herd located in Wyoming, Montana and the Dakotas. The bloody curtain rang down on the last of the sixty million, or more, buffalo by 1884.

The tool most responsible for killing these millions of animals was the Sharps rifle. Of course, other rifles were used, but the majority of the rifles preferred by the professional were Sharps. The Sharps's reputation for long-range accuracy and knock-down power began in the Civil War with Berdan's Sharpshooters. These men were armed with a single-shot breech-loading percussion-cap model that used a paper or linen cartridge of .54 caliber. The Confederate troopers learned to stay a long way away from Berdan and his Sharpshooters because of the range and killing power of the Sharps.

The paper or linen cartridges gave way to a metallic cartridge model in 1869. As the buffalo slaughter gathered momentum, the hunters asked the company to develop a load that was powerful enough and accurate enough to bring down an 800- to 1,500-pound critter at up to five hundred yards. Sharps responded with rifles of various calibers, including the .44-90, the .45-70 and the .50-100. The first number is the bullet caliber while the second is the grains of powder in the metallic case. A professional hunter using any one of these loads could kill a buffalo at five hundred yards. The .50-100 became known as the "Big Fifty" or the "Texas Fifty" and was considered unequaled for killing off the southern herd. This background will become meaningful in the following bank robbery account.

The following quotes are from the *Lincoln* (Kansas) *Sentinel*, November, 15, 1894:

> *The latest Kansas town to fall into line with the prevalent bank robberies is Sylvan Grove, a small town in this county, about 15 miles west of Lincoln.*
>
> *About 8 o'clock last Monday afternoon three men, well armed and mounted on fine horses, rode into Sylvan Grove. One of them at once rode up to a stone hitching post in the rear of the Sylvan State Bank, and directly in front of A. Karlowske's blacksmith shop. He dismounted and hitched his horse to the post and then leisurely walked into the bank. In the meantime his companions had halted in the middle of the street in front of the bank…The desperado who had entered the bank at once walked up to the cashier's window and requested small change for a silver dollar. Will D. Schermerhorn, assistant cashier, was in charge of the bank, the cashier, John Calene, being absent in Dickinson county [sic]…complied with his request…He then…threw open his coat and drew a revolver…suddenly presented it at the cashier's head, with the exclamation, "Don't holler, or g--d--- you, I'll blow your brains out."*

Western history buffs will understand the term "sand" when applied to someone with exceptional courage and determination. Schermerhorn had an abundance of sand, as proved by the events that followed:

> *He then walked around the counter and producing a canvas bag or sack held it out to the cashier and ordered him to open it and shove the money in.*
>
> *Mr. Schermerhorn refused to do so, and after a little parlaying the fellow suddenly struck him on the forehead with the revolver. Although not hurt very much Mr. Schermerhorn had the good sense to at once drop to the floor—a very unfortunate thing for the robber, as his body covered from view a Sharp's [sic] rifle which lay on the floor. The robber then hurriedly helped himself to $1,734, overlooking a $2,000 package which lay further back in the safe. After the money was put in the sack the robber enquired if the back door was unlocked, and upon ascertaining that it was not, he compelled Mr. Schermerhorn at the point of the revolver to unlock it for him…left the bank and walked towards his horse…*
>
> *In the meantime quick-witted, courageous young Schermerhorn had picked up the Sharp's [sic] rifle, run out the front door, stepped around the corner of [the] building, and taking aim at the desperado just as he flung the sack on the saddle of the horse, fired the only load in the rifle. A steady*

hand and a brave heart, however, made up for the lack of ammunition, and one more desperado was ushered into eternity.

The ball entered the man's body just back of the right arm and came out at the left side of the breast near the nipple, passing through the heart, killing him instantly, the hitching post being completely bespattered with blood.

Did the robber not see the Sharps before the cashier fell down or when he was ordered to get up and unlock the door? It seems unlikely. Or did he not view it as a threat because it was a single-shot weapon or perhaps didn't expect a young bank cashier to be capable of handling a weapon of any kind? It was a grievous error of judgment on the bandit's part because a Sharps's round through the heart is 100 percent fatal.

One bandit was down, but young Schermerhorn still needed a lot of sand because he apparently didn't have any more ammunition for the rifle, and the two other robbers still had to be dealt with.

The two other robbers now commenced firing rapidly at Schermerhorn, and also made frantic efforts to get possession of the sack of money and make the dead robber's horse jerk loose, but Schermerhorn kept dodging around the corner of the building, snapping his empty rifle at them. Several of the robbers' shots struck the building. Wm. Brumbaugh, one of the proprietors of Brumbaugh & Bowen's livery stable, had heard the firing, and grabbing a revolver…commenced firing at them. This attracted their attention, and compelled them to give up all hopes of securing the dead robber's haul and putting spurs to the horses they galloped off in a northwesterly direction. Before leaving, however, they fired several shots at the body of their fallen companion, undoubtedly upon the principle that dead men tell no tales. Schermerhorn at once secured the bank's money, and the first bank robbery in Lincoln county [sic] *was a failure.*

In this case, the dead man did tell something about the professional bank robbers at that time. First, they did make mistakes, and some of them did take almost extreme measures to be prepared, as evidenced when the body was searched.

The dead robber was at once taken into an adjoining vacant building and searched for evidence as to his identity. Two medical prescriptions for wound liniment, dated Oct. 10, 1894, given by Dr. Grattan, of

Morganville, Kan., were found, also a slip of paper having the following address written upon it: "J.S. McKee, 1613 Hickory street, St. Joseph, Mo." Two flasks of whisky with St. Joseph labels on the bottles, two large Colt's revolvers, a cartridge belt which covered the entire body, containing nearly 300 cartridges, bandages and liniment, two large plugs of "Horse Shoe," tobacco, $25 in gold and several dollars in silver. He was fairly well dressed. Everything about the fellow showed the desperado. The bandages and liniments indicate that he fully realized that he carried his life in his hands.

His name was Anthony McKee, and he had a place in the Blue Hills region of Mitchell County. Mrs. McKee, the wife of the dead bandit, was held in custody at Sylvan until Wednesday morning but was released, as it could not be proved that she was connected with the gang. He was buried at the Vesper Cemetery. McKee was a brother-in-law to the outlaw Henry Starr, who was the nephew of Belle Starr.

Western novels, movies and TV have instilled in the average citizen the belief that a vigilante is someone who takes the law into his own hands and leaves the bad guy dancing at the end of a rope thrown over a handy tree branch. The word can mean that, but it can also mean a legal process of dealing with criminals.

The vigilantes organized by the KBA (Kansas Bankers' Association) included almost four thousand members in the 1920s and 1930s and were described by the KBA: "They are armed; they carry commissions as deputy sheriffs; they are bonded; the sheriff [of whatever county] is their head; each community is to work out its own individual plan of defense, but all communities are to co-operate as a whole for general protection.

"They are not taking the law into their hands; they are merely increasing the ability and the scope of the law to fulfill its function."[99]

The Kansas Bankers' Vigilante Committee was launched about 1925 and described its function this way:

Kansas bankers wielding pistols and rifles, formed into vigilante squadrons and helped break the wave of bank-burglary and holdups which swept the Midwest back in the early and middle twenties.

Gunslingers to Gangsters

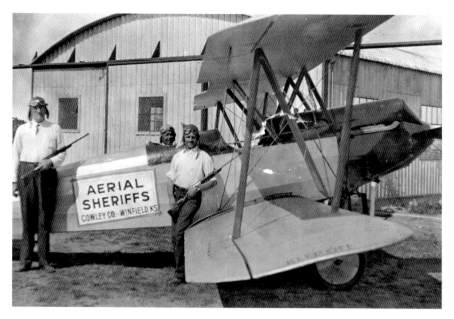

The aerial sheriffs of Cowley County, Kansas. *Courtesy Cowley County Historical Society.*

With the advent of automobile and improved roads assisting swift getaways [sic], *the fast-riding underworld elements turned to banks in the plains and prairie country as easy prey.*

In the absence of a state police system, bankers decided they would have to organize for self-protection, so they formed vigilante committees by communities and counties throughout the state…

By the next year, a majority of the counties had committees formed, nearly 4,000 vigilantes spread across the state with guns near at hand waiting for call…The vigilante committees held frequent meetings and outings for target practice and instruction on use of fire-arms. In September 1926, the First Annual State Shoot for vigilantes was held at Fort Riley upon invitation of General Booth, commander of the post…

The committees used various methods to spread the word and put the fear of God into the underworld. The Crawford County Vigilance Committee displayed guns in the bank and store windows reading: "The Crawford County Bankers Association is **LOOKING FOR TROUBLE***," and "There will be about 75 rifles like these in Crawford County* **LOADED FOR BEAR***."*[100]

The arms and ammunition for the vigilante groups were provided by the KBA, the county banks and the county bankers' association. These groups also bore the cost of transportation and lodging for the members who attended the training at Camp Funston on the Fort Riley Military Reservation.

All too many Kansas banks were the target of dime-store criminals and organized crime during the Roaring Twenties, causing not only the banks but also citizens to push back. The Coffeyville banks offered:

> *One thousand dollars reward will be paid…for the arrest and conviction of each person who robs or attempts to rob, by daylight holdup or in a burglarious manner any of the Coffeyville banks. One hundred dollars reward will also be paid to any person or persons furnishing information leading to capture of each person who has robbed or attempted to rob any Coffeyville bank. For the purpose of this reward, the killing of any of said robbers will be deemed equivalent to arrests and conviction.*[101]

The last known bankers' vigilante group was still active in 1965.

Did they work? Yes, although there were probably instances where mistakes were made, but for the most part, they were effective. There are numerous examples where the vigilantes apprehended the criminals or, in some cases, killed them, which would hopefully serve as a deterrent to other criminals who considered breaking the law in a particular community where the vigilante group was active.

An example would be the counties of Johnson and Miami in eastern Kansas just south of Kansas City where the merchants in the town of Spring Hill formed a vigilante group to protect the town from gangs of criminals who regularly robbed and burglarized the town's businesses. This

A re-creation of the reward notice that appeared in the October 1919 issue of the *Kansas Banker* magazine. The $5,000 reward would have the buying power of approximately $68,000 in 2015. *Courtesy* Kansas Banker *magazine.*

group was active prior to the formation of the later vigilante groups associated with the KBA. The following quote is from a news article in *Daily Financial America* out of New York and datelined Topeka, Kansas, August 26, 1919:

> So Spring Hill merchants, physicians, lawyers, retired farmers and other citizens organized what were pleased to term "minute men," such designation being given only to those who were able, under a stop watch, to put on shirt, trousers, shoes and a hat and get from their bedroom to the front porch of the home in *exactly* one minute.
>
> The two banks of the town bought a large supply of the best rifles that can be purchased and they furnished ammunition in large quantities. Each man who made the test of dressing in one minute, even in the dark, was furnished with a rifle and ammunition. The men went down in the pastures nearby and worked at target practice until they were reasonably proficient and efficient in handling those guns.
>
> Each minute man has a telephone in his home. The central operator has instructions about ringing those telephones when she is given the alarm… The minute men all have designated jobs to fill…The minute man business sounds awfully funny to high salaried Hawkshaws and plain clothes men of the cities and may even make an ordinary "cop" smile. But it has produced results.

Colorado's eastern state line is eight miles due west of Manter, Kansas, which is situated on U.S. Highway 160 in Stanton County. The county was established in 1873 and organized on June 17, 1887. It was named for Edwin M. Stanton (1818–1869), who served as President Lincoln's secretary of war from 1862 to 1868.

The Manter State Bank was held up on March 14, 1930, by three men who had robbed five other banks and killed a deputy sheriff:

> Leaving a trail of damaged motor cars and wounded peace officers, even killing Deputy Sheriff C.A. Hickman at Eads [Colorado], the bandits were followed through to Hodgeman County, the last report coming from Sheriff Dubbs at Ness City.
>
> The actual apprehension was made by the Jetmore vigilantes under the leadership of Len H. Raser, with the co-operation of Sheriff

Haun and several officers and citizens of Hodgeman county [sic] and assisted by a large number of officers, vigilantes and citizens of Western Kansas.

The Protective Committee of K.B.A. authorized the payment of the maximum reward of $1,500.00 and Ocean A.&G. [Accident and Guarantee] Corporation [insurance firm] added $300.00...

Sheriff Haun of Jetmore has this to say of the vigilante system: "The successful apprehension of these confessed robbers of the Manter State Bank and five other banks in Kansas surely proves the value of the vigilante system in Hodgeman county [sic]. We cannot give them too much credit."...The three bandits, although confessing to and identified in the Manter robbery, were delivered to Colorado, convicted of murder of Deputy Sheriff Hickman and now await execution in August.[102]

The bandits were captured the next day, March 15, after being chased for nearly 140 miles over bad roads and no roads. And that is as the crow flies without accounting for any detours that the bandits might have taken to throw off pursuit. However, they couldn't shake the law, and as the robbers fled toward Eads, Colorado, Deputy Sheriff Coral Hickman and another deputy, W. Mosher, were notified of the Manter robbery.

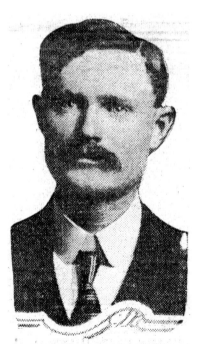

Deputy Sheriff C. A. Hickman.

Deputy Sheriff Coral A. Hickman of Eads, Colorado, was killed by robbers who had robbed the Manter State Bank in Stanton County, Kansas. *Courtesy findagrave.com.*

Coral and fellow deputy W. Mosher drove a Durant coupe to a spot four miles southeast of Eads to patrol the highway. They spotted the robber's Model A Ford as it approached town and gave chase. The bandits eventually stopped and Coral was killed in the ensuing gun battle. The bandits left him in the road, and by coincidence, Coral's brother Ed was the first to come along and discover the body. Ed rushed back to town and told Coral's

son, "Earl, I have the saddest news you will ever hear. Your father is dead. Those bandits shot him to pieces!" A local telephone operator notified all local towns and a posse was formed, including seven "air planes." The bandits were located the following day.

Coral's gold pocket watch had been struck by one of the bullets, and his widow Mamie kept the watch the rest of her life.[103]

"The robbers were convicted, hanged for murder and 100-pound weight did not break their necks, and all three strangled to death."[104]

The swift and deadly justice didn't deter two other bandits who entered the same Manter State Bank on August 22, 1934, and left with only about $600. After the robbers fled, a customer in the bank, Mrs. Hoopingarner, quickly notified the authorities, and the chase was on. "The pair was caught a couple of hours later in a pasture down toward Pritchett, and 30 hours after the robbery were sentenced to the state penitentiary by Judge Rindom in the district court. That was in 1934, and the second time Mrs. H.H. Hoopingarner was a victim of bank robbers."[105]

During the settlement of Kansas, Fort Harker was a major supply depot for forts located farther west. The location was first along the banks of the Smoky Hill River some three miles east of Ellsworth on the Santa Fe stage route where it crossed the Smoky Hill. The fort, established in 1864, was originally called Fort Ellsworth for Second Lieutenant Allen Ellsworth, who was the first commander of the post. The name was changed to Fort Harker on November 11, 1866. Besides serving as a supply depot, it garrisoned troops for campaigns against the hostile Indians, for protection of early settlers and to guard construction crews building the Kansas Pacific Railway. In April 1872, the fort was closed, and the military reservation was transferred to the Interior Department eight years later.[106]

The town of Kanopolis, adjacent to the fort, remained, and its developers envisioned and hoped that it would become the capital of Kansas. With unbounded optimism, the town site was laid out to accommodate a city of 150,000 residents. It was incorporated on January 6, 1887, and by 1890, it boasted of two large hotels, a hardware store, a roller mill, woolen mills, a foundry and iron works, a carriage works, an earthenware works, an elevator, the Union Pacific depot, three churches and a school.

Optimism was fine, but the one other quality necessary to survive and succeed on the Kansas frontier was the toughness and willingness to confront any threat to life and fortune. These qualities were still present in the town thirty years later when bandits robbed the town's Exchange State Bank.

The bank's president was James Cowie, and his wife was assistant cashier. They lived just a block away with their two sons, Richard and James Jr. The family was awakened on January 20, 1917, by five loud explosions coming from the bank. They dressed, grabbed weapons and ran toward the bank, where they confronted five men who had blown open the vault and safe with nitro, scooped up the cash and were going through the drawers within the vault. One robber was standing guard at the back door while the others were ransacking the vault.

When the guard at the back door saw the Cowies approaching, the thieves opened fire, and Mr. Cowie and son returned fire. Meantime, "Mrs. Cowie, revolver in hand, forced her way to the front of the bank and returned shot for shot with the bandits. She was wounded in the arm but kept on firing. The robbers fled to their motor, leaped into it and raced north. A posse followed, Mrs. Cowie being among the foremost members and not minding the wound she suffered. The robbers escaped, however."[107]

It was estimated that at least fifty rounds were exchanged during the confrontation, and surprisingly, no one was wounded other than Mrs. Cowie. Even though the loss was covered by burglar insurance, it did give notice to anyone considering robbing the Exchange State Bank at Kanopolis that they would encounter armed resistance.

Authorities first believed the robbers headed east to Salina, then south to Hutchinson and then to Wichita. This was probably incorrect since a detective for the Union Pacific Railroad received a telegram at Manhattan stating the robbers boarded a special freight train east of Kanopolis and forced the train crew to haul them into the hills between Kanopolis and Brookville. Apparently, the villains were never apprehended.

Bad planning, sheer stupidity and watchful vigilantes eventually led to the end of a gang of Wichita bank robbers. The demise of Ray Majors and his henchmen began about 2:30 p.m. on a quiet afternoon in Elkhart, Kansas, which is located in Morton County. Elkhart was probably chosen for the

gang's heist because it is right on the Kansas-Oklahoma line, and the robbers could be across the Oklahoma border in less than a minute.

Viewing the attempted robbery in retrospect, it could qualify for a comedy of errors except for the violence involved. Their first error was not keeping up with news concerning law enforcement and banks. They should have known that the Kansas Bankers' Association was successful in organizing vigilante groups to watch for, and respond to, any suspicion of a bank robbery.

Don Welch, who was a watchful member of the Elkhart community vigilantes, was working just two doors down from Elkhart's First National Bank and observed two strangers walking toward the bank. He watched as both men drew revolvers from their pockets as they prepared to enter the bank. Welch immediately realized a bank robbery was happening, so he ran into the hardware store and grabbed his .30-30 Winchester deer rifle. Guessing that the robbers would flee southward toward the state line, Welch ran to the back door to position himself for a shot at the fleeing bandits.

Mistake number two was drawing their revolvers in the street before entering the bank. Error number three involved firearm expertise, or lack thereof, on the part of the bandits. The would-be robbers, Ray Majors and Frank K. Cody, entered the bank and shouted, "This is a stickup!" They then shouted orders to the employee and customers, but one elderly customer was hard of hearing and didn't realize what was happening so innocently reached into his pocket for a handkerchief. Thinking the old gentleman was reaching for a gun, one of the bandits leaped forward and hit the old man in the head with his gun, which caused the gun to discharge. Of course, that alerted everyone to what was happening in the bank. This caused a repeat of error number one because another member of the vigilantes, Reed Garton, grabbed his high-powered rifle and prepared to join the fray.

Majors and Cody by now realized they needed to get away as soon as possible, so they quickly scooped up about $850 from tellers' cages before running out the door and jumping in the getaway car. Frank Albertson was the wheelman for the gang, and as the others climbed into the Buick coupe, Majors knocked a shotgun lying on the front seat onto the floor, causing it to discharge. The shot struck Albertson in the right leg, but he managed to slam the car into gear and race south out of town. Along the route, both Welch and Garton opened fire on the car and wounded Albertson in his other leg.

Error number four involved money management. The two robbers threw their loot into the back seat as they jumped into the getaway car. It can get sizzling hot in southern Kansas in July, and the Buick had no air conditioning;

therefore, they had left the automobile's windows down, which allowed the paper money to fly out the open windows as they sped south. Of the meager haul from the bank, about $500 flew out the window! And the remaining $300 was covered with blood.

After discovering they were losing the stolen money, they put into play the one bit of planning that did work: they threw enough roofing nails out the windows to disable the posses' pursuit cars. Although they did make one good decision, it wasn't long before error number five stopped them cold in their tracks. On their way to their hideout near Arnett, Oklahoma, they had to cross the Cimarron River. Maybe Albertson was still driving and because of his injuries couldn't negotiate the crossing, or maybe another driver didn't know how to drive through a river crossing. They became stuck in the sand, making it necessary to enlist the help of a farmer to free the Buick. Of course, this made it easy for authorities to follow their route.

Later, the getaway car was found abandoned near a river south of Arnett. They had tried to burn the car, but the authorities managed to trace the vehicle to Wichita (error number six), where it had been reported stolen the night before the Elkhart robbery. Back at the gang's hideout, Majors and Cody attempted to wash the blood-soaked money that was left from the bank robbery. After washing the bills, they ironed them, hoping to be able to pass the bills to pay for a doctor to treat Albertson's wounds.

A member of the gang was sent from the hideout to Wichita to get Majors's wife, Ollie, and a doctor to treat Albertson's wounds. This left Majors, Cody, Albertson and one other gang member at the Oklahoma hideout. When Ollie and the doctor arrived at the hideout, the doctor removed the bullet from Albertson's leg and treated the wound. It took $200 of the remaining $300 to pay the doctor, which left only $100 net profit for the bank robbery.

Some days later, when Mrs. Majors was gone from the hideout, Cody and Majors began to argue, and after several minutes, Cody grabbed his .45 revolver and shot Majors twice in the chest. When Mrs. Majors returned, she found Cody and Albertson gone and her husband lying in bed bleeding from two gunshot wounds.

Error number seven: marrying the wrong gal. Mrs. Majors managed to get her husband into the car and drove him to Arnett, where she dumped him out on the courthouse lawn. The sheriff was notified and took him to a hospital where Majors was treated. When the sheriff questioned the injured man, he told the officer his name was Joe Wilson and that he'd been shot by Ray Majors. He denied his identity clear up to his trial, where he was

convicted on several counts and remanded to the state penitentiary to serve out the rest of his life.

Eventually, the authorities arrested seven persons in addition to Majors, Cody and Albertson. All of the gang except these three were released. Cody apparently had a sense of humor because as he was being loaded into a law enforcement car, he told those from Elkhart, "Try and have more money on hand when we come back the next time." The Elkhart boys cracked back, "The next time we'll have still less money and still more guns."[108] Cody and Albertson were sent to the state pen at Lansing, and after their release, they never tested the Elkhart boys to see if they did have more guns.

Majors died after serving five years of his sentence. He had suffered nineteen gunshot wounds during his short and violent criminal career.[109]

7
THE PROFESSIONALS

The Business of Robbing Banks

As settlements pushed west from the Mississippi River, bank robbers and bank burglars were viewed by many as Robin Hoods of the plains, taking from the rich and powerful, which somehow was viewed as helping balance the books of right and wrong during some very trying times. Banks were especially unpopular in the farm belt during the Depression and dust bowl during the 1930s, when banks foreclosed on many farmers and businesses.

Prior to the Dirty Thirties:

> *The end of the war should have signaled western bankers that tough times lay ahead, but they hardly expected trouble to come in the form of bank robberies. Despite the appearance of security, to a greater extent than ever before banks proved susceptible to robbery, for the advent of the automobile gave thieves unprecedented advantages over lawmen. Easily followed horseshoe tracks gave way to invisible trails on well-traveled roads, and without prior knowledge of the direction of escape—something most criminals did not routinely discuss—the pursuing posses found that their adversaries had insurmountable head starts. Primitive radio communications could not offset the advantage of speed held by the robbers.*[110]

The downside of the automobile was its limited off-road capabilities compared to a horse. Flat tires were the curse of early autos, and there wasn't a filling station on every corner. The professional automobile bandit

Notorious Kansas Bank Heists

Denver's Auto Bandit Chaser was designed as a response by law enforcement to counter the epidemic of bank robberies during the 1920s and 1930s. It was a modified Cadillac with bulletproof armored plating and a bulletproof windshield. *The Denver Public Library, Western History Collection, 1X-29731.*

carefully preplanned his getaway route, carried extra tires mounted on rims and either carried extra gasoline with him or stashed some cans of gas along his getaway route.

In December 1922, the *Kansas City Star* lamented that "a new element in Kansas City's underworld—youngsters inspired by harem-scarem novels and the melodrama of the moving pictures, nerved by corn whisky, aided by the motor car and influenced by the moral reflex of the war—all this has led to the development of a new type of gangster and the organization of bandit bands as yet not thoroughly known to the police."[111]

Two years later, the view of bank robbers was still changing, according to an article in the *Kansas Banker*. "In the old days the 'yegg' was, in most cases, a grown man, but the average modern 'bandit' appears to be mostly young men in their early twenties, of the wise 'cracking' 'gun-flashing' silk-shirted, cake-eater type, each the proud possessor of a supposed-to-be smart 'Broad.'"[112]

Some robbers and thieves may have robbed to supply themselves or their family with the necessities of life: food, clothing and shelter. During the 1930s, there were times when 25 percent of the workforce was unemployed.

Hungry children can drive a parent to extreme measures. This cannot be said for those robbing or burglarizing banks and taking far in excess of their immediate needs.

"Slick" Willie Sutton was good at disguises and bank robbery. His oft-quoted remark that he robbed banks "because that's where the money is" may not have originated with Sutton, who gave another reason for robbing banks: "Why did I rob banks? Because I enjoyed it. I loved it. I was more alive when I was inside a bank, robbing it, than at any other time in my life. I enjoyed everything about it so much that one or two weeks later I'd be out looking for the next job. But to me the money was the chips, that's all."[113]

Bank robbers ran the gamut from inept amateurs to highly professional gangs that operated like businesses. The Newton brothers were the exemplary professional gang that successfully robbed over eighty banks and six trains. One of their jobs was the biggest train robbery in American history.

Interviewed when he was eighty-four years old, Willis Newton explained their operation: "Bonnie and Clyde was just silly kids bound to get theirselves killed…We wasn't at all like them. We wasn't thugs. All we wanted was the money, just like doctors, lawyers and other businessmen. Robbing banks and trains was our way of getting it. That was our business."[114]

A significant step was taken to help deter bank robberies in the United States by the passing of the Banking Act of 1835, which stated "that the robbery of or similar offenses committed against any insured bank has become a federal offense, punishable by imprisonment in the federal penitentiary for a term not to exceed twenty years. The killing of any person by a bandit in the robbery or attempted robbery of any insured bank, or the forcing of any person to accompany the bandit in making his escape is a violation of the same section and may be punishable by death."[115]

To combat the cake eaters and professional bank robbers, the state's general statutes[116] of 1868 allowed for only one sheriff and one undersheriff for each county in Kansas. The sheriff or undersheriff could deputize as many as he saw fit to help enforce the law. But it quickly became obvious that law enforcement officers were unable to cover the entire county, respond to every crime and capture every criminal. They did do a remarkable job with the resources available to them. However, once the bad guys were apprehended, they had just as much trouble keeping them behind bars as they did catching them.

For example, the four men who robbed the Cuba bank were captured but escaped jail before they were tried. Their escape was reported in the *Kansas City Journal* on December 31, 1910.

Dan Carney—alias Dan Sharp, Shirley Grant, Crippled Dan and Dan Minor—was sentenced to ten years in prison for robbery of the Beattie bank, but he soon broke jail and escaped.

The October 28, 1911 *Topeka Journal* noted that Neil Muicahy, sentenced to ten years for robbery of the Waterville bank, broke jail and escaped.

Some of the bank robbers, rather than be captured and sent to prison, became their own judge, jury and executioner. Earl Bullock, who robbed the Eudora bank, killed himself when it was certain that he would be captured. The man who robbed the Paradise bank a few weeks earlier killed himself when he was surrounded, but very little of the money taken by him was recovered. Another bad guy held up four men and robbed the bank, but a posse surrounded him, and he shot and killed himself rather than submit to capture.[117]

The professionals just didn't resort to this extreme. They wanted to survive so they could rob again.

The Arma State Bank of Arma, Kansas, located in Crawford County had the distinction of being robbed on June 2, 1919, by allegedly the most successful gang of bank robbers the era ever produced. The Newton brothers, Willis, Joe, Jess and Willie (Doc), were Texans who over their career had carried off "more loot than Jesse and Frank James, the Dalton Boys, Butch Cassidy and all the other famous outlaw gangs put together."[118] Some jobs they pulled alone, and for others, when the situation required it, they would use another man or two. This was the case when they robbed the bank at Arma, Kansas:

> *We monkeyed around there and got together with Frank—he's the old bank robber I turned out of the penitentiary and did the night job at Winters with. We had a little Dago with us from down in Henryetta. That little Dago had some people that lived up in Kansas in a mining town. That's right when all them Victory Bonds arrived. That was the last sale of bonds. And everybody bought them by the pocketfuls. They paid more interest than the other bonds did, the Liberty and Victory Bonds.*
>
> *So he said he knowed a little town up there and knowed some Dagos lived there right close…Sat around all day, in a nice Buick car. Then he borrowed two shotguns off them Dagoes [sic]…and Sunday night we go over to rob the bank at Arma, Kansas.*[119]

Beginning in 1917, U.S. citizens purchased $17 billion of war bonds that, in some cases, could be cashed by anyone who had them in their possession. *Courtesy Library of Congress.*

They robbed the bank by chiseling a hole through the concrete vault wall. Willis Newton said the vault wall was only about four inches thick. A newspaper reporter disagreed:

> *The wall of the vault through which the robber had to dig is more than a foot thick and is made of solid concrete…Apparently the opening was cut with chisel and hammer though it is possible that the excavating may have been helped with a small amount of explosive.*
>
> *The burglar-proof safe, which is inside the vault had apparently not been tampered with…The stormy night was favorable for the robbery and the battering through the thick wall of concrete was not heard by Marshal Charles O'Donnell, who lives next door.*[120]

About four o'clock in the morning of the robbery, one of the gang called Slim thought the robbery had been discovered and that people were going from house to house spreading the alarm.

> *I said, "No, that's miners going to work with lights on their heads. I watched them go."*
>
> *But old Frank considered himself the boss, and he said, "We got all the money we'll ever need." So we took out. They never knowed the bank was robbed until eight o'clock the next morning. And it was raining and all muddy roads, and we'd swing around a little town on our getaway route and get stuck. And we had sixty-five thousand dollars in Liberty Bonds and Victory Bonds. But we'd left $200,000 or more in the vault, and that's where we'd all of been rich, right there.*[121]

The above first-person account of the robbery was given during interviews with Willis and Joe Newton, who were eighty-four and seventy-two years old, respectively. Jess Newton had died in 1973, and their brother Willie (Doc) Newton was at that time in a nursing home. It was Willis and Joe whom the authors, Claude Stanush and David Middleton, interviewed beginning in 1973. In 1994, their book, *The Newton Boys: Portrait of an Outlaw Gang*, was published by the State House Press of Austin, Texas.

After their retirement from robbing banks, they lived near Uvalde, Texas.[122]

Unfortunately, the law did not consider robbing banks and trains as a legitimate business venture. However, there was never a doubt that it was an adventure for the Newton brothers and the lawmen who pursued them.

Three nights after the Arma robbery, the Tyro State Bank at Tyro, Kansas, was also robbed. This time, explosives were used to blast open the vault, and the loot taken was estimated at $25,000. The robbery wasn't detected until the cashier opened the bank the next morning. Although initially there were no clues to the identity of the heisters, there were enough similarities to the Arma job that officials believed it was the work of the same gang.[123]

The reward offered for the Arma robbery was $4,000 and another $2,000 for the Tyro bank job. It isn't known if any one person ever collected the full sum of both rewards, but if so, the $6,000 at that time would be the equivalent, in buying power, of over $82,000 today.

An interesting sidebar to the Newton brothers' careers as bank robbers is Willis Newton's description of one of their train heists:

> *A train was easier to rob than a bank because at night you had them trains out there in the dark and in the country. There was nobody to bother you. All you had to do was break the windows, tell them to come out, and usually they did. Banks meant a lot of work. They was hard work—and dangerous. Trains, you could just plan your getaway before the job, watch the train, do it, and scatter. It was a lot safer.*
>
> *With trains, we always tried to get a big one, but we kept missing them. Then we did get that big one when we robbed the Chicago, Milwaukee & St. Paul railroad at Rondout, Illinois, just twenty miles or so out of Chicago, on June 12, 1924. That's a day I'll never forget. We got $3 million in cash and bonds, and it was the biggest train robbery ever in the United States, before or since.*[124]

One of the extra men the Newton brothers employed for this robbery accidentally shot Doc Newton four or five times. Seeking medical attention for their wounded brother led to their arrest and ended their careers.

H.G. Wells, a noted English author, advised his readers to "adapt or perish." Predictably, some yeggmen perished while others adapted. Whether bank robbers and burglars are smarter or dumber than the average citizen is a debate that has no answer. If you compare IQ scores, some criminals will no doubt score far above average while, as suspected, some will score far below average. But we have to give them their due

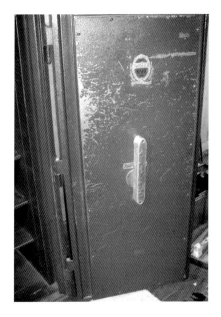 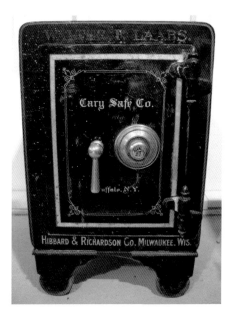

Left: The long vertical device mounted on the safe door contains a vial of tear gas that can be set off by an attempt to burglarize the safe. *Courtesy Anthony Martin.*

Right: Old, square-type safes were much easier to blow open with dynamite or nitroglycerin than the later cannonball design. *Courtesy Anthony Martin.*

when it comes to adapting to the changing methods used by banks to secure their customers' wealth.

By the late teens, safe technology had advanced to the level that made getting inside certain safes almost impossible for even the most professional burglar. In the same magazine that ran a story of a burglary at the Buhler State Bank on January 8, 1919, there was a half-page advertisement for the York Safe & Lock Co. of York, Pennsylvania. This company manufactured and sold the Ely-Norris Manganese Steel Bank Safes. The ad copy proclaimed, "Note: 187 ounces of Nitro-Glycerin fired in 57 shots in three (3) tests failed to open the Ely-Norris Safe."[125]

These advances in safe security weren't challenged by intelligent burglars who quickly adapted, as evidenced by the burglary of the Buhler bank. The thieves didn't even bother attempting to open the safe but concentrated on robbing the safety deposit boxes, which yielded the bad guys some $43,000 in Liberty Bonds and other securities. These bonds were issued by the U.S. government to help finance World War I. In April 1917, the Emergency Loan Act authorized the issue of $5

This fully restored Ely-Norris cannonball safe was as burglar proof as any safe of its era. *Courtesy Anthony Martin.*

billion in bonds; in October of that same year, the Second Liberty Loan authorized an additional $3 billion in bonds. There were two more offerings in 1918, the first being in April in the amount of $3 billion, and in September, the feds issued an additional $6 billion. The bonds were sold to individuals who often placed them in bank safety deposits to protect them from theft because "bonds lost or stolen can be cashed by the holder."[126]

This, of course, was a $17 billion juicy plum that the criminals were quick to begin harvesting. This burgeoning theft of bonds from safety deposit boxes introduced another dilemma for the bankers. First, can the contents of the boxes be covered by insurance? The answer was that insurance companies declined to extend coverage to safety deposit boxes. One of the reasons given was that the boxes were private and their contents known only to the renter and the banks have no access to the boxes and no control over them.

The next question for the banker and the bond owners was to determine where they stood legally. At the time, it was considered that the stolen bond was negotiable in the hands of the innocent holder. Therefore, at that time, there was no recourse for the rightful owner.

Did the bank have any liability for the loss of stolen items? "The best legal information is to the effect that no such liability rests upon the bank, indeed no liability at all except for due diligence. The bank has not become an insurer of the miscellaneous contents of a box, of which the bank can have no knowledge; it has simply sold space for a small consideration—a mere rental proposition."[127]

A short time after the Buhler robbery, it was reported that a portion of the stolen securities had been located. Checking with known and suspected fencing operations was one of the first places officers checked. It proved much easier for the burglar to fence the stolen bonds than to try to cash them. There was a fence operating near Hutchinson, Kansas, dealing in stolen goods, including bonds, from neighboring states as well as from

Kansas. The June 22, 1929 issue of the *Hutchinson* (Kansas) *News* ran a story of a "fence" in or near that city.

> *Somewhere in Hutchinson or nearby community is a "fence" which disposes of loot stolen in bank robberies and other holdups and its presence is widely known by bandits and other underworld characters.*
>
> *Recent developments in bank robbery cases throughout this section of the country have convinced local peace officers that a fence is in operation on a huge scale. A "fence" in the parlance of the underworld, is a person or persons who handle stolen goods for the convenience of the robbers.*
>
> *A "fence" is a highly essential person in the business of highway robbery since a safe disposal of the loot is very important. In fact, bank robbers know just exactly where they can dispose of money or bonds before they stage a holdup. Making arrangements with the "fence" is regarded as one of the important pre-robbery details.*

Herein lies another problem for banks and law enforcement personnel:

> *Within the past half dozen years, developments in major robberies committed in the southwest have sent detectives and sheriffs to Hutchinson in search of the stolen loot…About three years ago officers from an Oklahoma city recovered approximately $25,000 worth of stolen liberty bonds from the local "fence."…At that time one or two prominent local men were said to have been involved in the disposal of the Liberty bonds and an investigation was launched by the attorney general's office. However the affair was hushed up and no action ever was taken.*

The protection of "important" and "prominent" men in local communities often delayed justice. Therefore, it would take a while to solve the Buhler bank theft, but the law was working on the robbery along with dozens of other bank robberies in the state. Eventually, authorities in Hutchinson, Kansas, charged a man named James Martin with cracking the vault of the Buhler State Bank. Martin was a sometime associate of the Tom Pendergast machine that controlled much of the crime in Kansas City. Martin was one of five men who robbed the Drovers National Bank of Kansas City located at the Kansas City Stockyards in January 1921. The haul was $97,000 in cash and qualified as the largest bank robbery in Kansas City up to that time.

Another term used by criminals for a fence is a market. Willis Newton and his brothers knew of many markets in several states where the gang

operated. "Billy had a market in Kansas City, some banker, some fence, and he could sell them bonds, so from there we went back to Kansas City. I had a market with bankers from Tulsa to Kansas City to Memphis to Chicago. All the way up, I had a banker I could sell them bonds to."[128]

It didn't have to be paper to be fenced or marketed, it just had to be valuable. The Fleagle gang stole a car in Lamar, Colorado, to use in the Kinsley, Kansas bank robbery. "This machine was later traced to a town in Kansas where it was in the possession of a former deputy sheriff named Joe Marvin. Besides the Lamar car there were $150,000 worth of automobiles recovered from Marvin. He was a fence for thieves and was convicted and sent to jail."[129]

Fort Scott, a United States military post situated on the Leavenworth to Fort Smith Road, was established in 1843, and thirty years later, it was abandoned after enduring the border strife between Kansas and Missouri as well as the Indian-white conflicts of the westward expansion.[130]

Hiero T. Wilson, the post's sutler, was founder and leader of the town of Fort Scott, which is today home to just over eight thousand people. Since the cessation of the border conflict and peace between the Indians and whites, life has been much quieter. However, occasionally there comes a reminder that the human race still has a few who choose not to abide by the law.

One of those reminders happened on June 17, 1932, when four armed men robbed the Citizens National Bank and escaped with $32,000. It was a nice take for the time period, but it wasn't the biggest or the baddest bank heist pulled off during that era. It certainly ranks high in interest, though, because one of the heisters was Harvey Bailey.

> *In the minds of lawmen and his fellow bank robbers, Harvey Bailey in 1932 was the undisputed king of bank bandits. He had never been captured or charged, except for a minor clothing theft in 1920. He was credited with developing techniques in bank robbing that are used today. His meticulous planning was so detailed each person involved knew exactly what to do in any eventuality. In his twenty-nine known robberies, not a single bank official or customer was shot, although several were clubbed over the head when things didn't go according to plan. Only one of his fellow*

robbers was killed in the execution of a job, having been struck in the head by a wild bullet while they were fleeing.[131]

That may not be a bad record, but there were other outlaws who claimed the title of king of bank bandits. Henry Starr insisted that he had robbed more banks than any other man. Some historians credit the Fleagle gang with 60 percent of all bank robberies in Kansas and neighboring states as well as California. "The Newtons had robbed eighty banks and six trains, and had acknowledged carrying off 'more loot than Jesse and Frank James, the Dalton Boys, Butch Cassidy and all the other famous outlaws gangs put together.'"[132] Given human nature with its pride and ego, there are other criminals who would gladly throw their hat in the ring as being the king of bank robbers during the outlaw and gangster eras.

There were some facts that did set Harvey Bailey apart from the amateur bank robbers during that time:

> *Bailey could case a bank in a single visit. His memory was uncanny. With one look at a teller's cage, he could mentally photograph the number of tills, any wires leading to an alarm, or other pertinent information needed to complete a robbery in six to eight minutes. For him, proper planning and execution included a fail-safe escape plan. Bailey's utilization of country roads to avoid major-highway roadblocks was perhaps his greatest contribution to the art. He perfected the method of "running the cat roads." He would spend days driving on farm-to-market roads surrounding an area where he planned a robbery. He referred to these roads as cat roads because cats were about the only ones who could use them after dark.*[133]

All of the gang members who robbed the Fort Scott bank were soon caught, and Bailey was sent to the Kansas pen at Lansing. On Memorial Day, May 30, 1933, Bailey and ten inmates escaped from Lansing, and due to Bailey's knowledge of the cat roads, five of the ten escapees were able to avoid capture for a while.

Police and citizens immediately gave chase to the fleeing bandits after the Fort Scott robbery but were stopped cold when they encountered nails and broken glass that had been scattered on the road. This effectively ended the chase.

Bailey was a habitual criminal and escape artist and had

spent twelve years in Alcatraz before being transferred to Leavenworth on August 11, 1946. In 1960, as a first step toward returning to civilian life, he was assigned to the federal institution at Seagoville, Texas, a minimum-security prison. When he was finally paroled in 1962, the state of Kansas had a detainer against him resulting from his escape in 1933, and he was returned to Lansing. On March 31, 1965, he was paroled and accepted a job as a cabinetmaker in Joplin, Missouri. He was seventy-eight years old…Bailey's amazing memory remained as steadfast as his hatred for J. Edgar Hoover, and he recalled minute details of his twenty-nine bank robberies with amazing clarity…On March 1, 1979, he died in a Joplin hospital after a series of kidney problems. He was lucid to the very end.[134]

An interesting sidebar to the story of the Fort Scott robbery is that three other men who had nothing to do with the heist were arrested for the robbery and sentenced to Lansing, where Bailey was also serving time.

If Kansas is the land of sunshine, sunflowers and sonsofbitches, then Eddie Adams is right up there at the top of the list, along with Major and Minor Poffenberger and the twins Ray and Walter Majors.

Adams was a homegrown native of Kansas, having been born on a farm near Hutchinson, Kansas, in 1887. His real name was William Joseph Wallace. His father died when William was young, and to escape his stepfather, whom he hated, he moved to Wichita, Kansas, and learned the barber trade.

While barbering in Wichita, he may have met Pretty Boy Floyd, who was also a barber as well as an acquaintance of John Callahan. Callahan ran a sort of finishing school for criminals during the transition period from outlaws to gangsters. Once he identified a protégé, he began his schooling as a bootlegger running liquor from Missouri or Arkansas into Wichita or by bringing drugs up from Mexico.

Nobody will ever know how many noted criminals Callahan sheltered or had dealings with, but in addition to Al Spencer, Frank Nash, Wilbur Underhill (who killed a policeman named Merle Colver in Wichita), Diamond Joe Sullivan, the Majors brothers, the two Poffenbergers, Eddie Adams, Frank Foster, and Pretty Boy Floyd, with whom his relationship is

established, there were many others. It is more than a mere conjecture that among these were Al Karpis…Jake Fleagle, Fred Barker, and others of that stamp who unquestionably operated at times in the Wichita area.[135]

Major and Minor Poffenberger and twins Ray and Walter Majors were four members of the Eddie Adams gang along with George "Gentleman" Brown, who robbed the Benton State Bank of $62,000 in cash and securities on August 10, 1919.[136]

Eddie Adams is said to have robbed over twenty-one Kansas banks during his short but violent career, during which he is credited with killing seven men, three of whom were law enforcement officers.[137]

Bank customer Margarette Good laughed out loud at the four men who entered the First National Bank of Ottawa, Kansas, just after 9:00 a.m. on November 2, 1923. The appearance of the four men suggested it was a Halloween prank that was two days late. The men were dressed in coveralls much too large and peaked engineer's hats, and handkerchiefs masked their faces just below the eyes.

The holiday spirit suddenly vanished when one of the men thrust a gun into the face of bank teller Ralph S. Hanes and commanded, "Everybody stick 'em up." Fifteen people, employees and customers, quickly lifted their hands while the robbers herded them to the bank vault. In less than fifteen minutes, the gang had filled pillowcases with $150,000 in cash and negotiable bonds. They then locked the employees and customers in the vault before leaving the building for their getaway car.

> *A workman, W.H. Jones, was removing screens from the adjoining Western Union building when the bandits trotted from a side door of the bank. Jones, in what he thought was excellent humor, remarked, "You fellows look like you just robbed a bank."*
>
> *A string of profanity and the sudden appearance of pistols froze Jones into silence. The bandits trotted on.*
>
> *Meanwhile, there was crisis among the patrons and employees in the vault. "It was a pretty tight fit." Hanes recalls. "Some of the women became hysterical. None of the men were exactly calm. There being no way to open the vault from the inside, we were in a pretty fine mess. Since there was no vent, we were using the air pretty fast.*

> *How long it took for help to arrive isn't known, but finally pounding on the door was heard."*
>
> *Straining to make himself heard, Hanes called the vault combination to those on the outside.*[138]

This is a prime example of the need for an escape means from inside the locked vault as well as adequate ventilation. These were incorporated in newer vaults as the manufacturers became aware of the problem.

The Ottawa bank holdup was one of the robberies committed by the Kansas Wolf Pack. However, their identity wasn't known until five years later when the gang was finally apprehended.

One hallmark of the gang was their preference for a getaway automobile:

> *The lawmen learned that the bandits, driving a high-powered blue-black Buick with side curtains, had driven west on 2nd Street and then turned north over a river bridge into open country.*
>
> *All towns in the vicinity were alerted. Posses were recruited and fanned out, armed with an arsenal of shotguns and rifles.*
>
> *The circle of pursuit gradually widened until it took in almost every corner of the state. But not a sign of the bandits turned up…After leaving town, they had simply steered their Buick to an isolated hay barn, closed the door behind them and waited out the search.*[139]

As already noted, eventually, all the gang members of the Kansas Wolf Pack were caught and brought to justice.

Other Kansas banks they robbed but weren't solved until their capture included the Citizens Bank of McPherson, the Exchange Bank of Marysville, the National Bank of Kinsley and the First National Bank of Larned.

8
THE PROFESSIONALS

The Kansas Bureau of Investigation

The Kansas Bankers' Association, the Kansas State Peace Officers' Association and the Kansas Livestock Association tried for years without success to persuade the Kansas legislature to sanction the organization of a small law enforcement group that could pursue criminals anywhere in the country. "Prior to 1939, law enforcement jurisdiction ended at the city limits and the county lines, and all responsibilities ended at the state line."[140]

The need seemed obvious, as between 1920 and 1939, forty-seven lawmen were killed in Kansas, which was the equivalent of one killing in every other county. Nevertheless, there was such a strong resistance to any thought of a state police that might lead to a police state that it seemed to paralyze the legislature on the issue.

The rapid escalation of crime during the 1920s and 1930s proved to be beyond the capabilities of law enforcement as it was structured at the time. Legislation gave sanction to a small force of special investigators who had the authority to pursue fugitives across borders. These investigators assisted local law enforcement in major cases in which the criminal fled local jurisdiction, which provided a strong argument for such a police force. In 1939, the Kansas legislature passed a bill to establish the KBI (Kansas Bureau of Investigation). The new institution would serve under the direction of the Kansas attorney general.

Most Kansans are undoubtedly aware of the FBI (Federal Bureau of Investigation) due to the movies and TV shows depicting its role in fighting the bad guys, and J. Edgar Hoover's controversial career also enhanced the agency's high profile.

Kansans, as a whole, probably have little knowledge of the KBI because it has maintained a low profile compared to other law enforcement agencies such as the Texas Rangers and U.S. Marshal Service. This, however, does not mean it isn't noteworthy or effective. The KBI's capture of the five escapees from Lansing in 1941 quickly proved how important and effective it is.

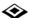

How much criminals are influenced by the careers of other criminals is unknown, but perhaps it was Clyde Barrow's letter[141] to Henry Ford that influenced George Hight and Frank Wetherick to steal a 1941 Ford V8 from a dealer's showroom in Satanta, Kansas, to use as a getaway car in their next bank heist. It may have been a good choice for a getaway car, but it was definitely a bad choice of banks to rob.

Hight and Wetherick were career criminals who had recently escaped, along with three other inmates, from the Kansas State Penitentiary at Lansing, Kansas. The escape was led by George Hight, who devised a plan for tunneling out under the penitentiary and escaping through a large drainage pipe. Considering that Lansing inmates mined coal located underneath the penitentiary, it isn't surprising that some resourceful criminals would eventually escape this way.

> *In 1941, among the worst in Kansas, and in Lansing, were George Raymond Hight, Kansas State Prison (KSP) number 9847; Frank Wetherick, KSP 3499; Lloyd Swain, KSP 9146; George Swift, KSP 2096; and John Eldridge, KSP 2559. All white males. All career criminals.*
>
> *Hight, age forty-one, was a Kansas oil field worker from Dodge City serving ten to fifty years for a bank robbery in Byers, Kansas, in Pratt County. Imprisoned in Lansing since 1927, he was also a car thief and burglar. Wetherick, thirty-one years old, from Pottawatomie County, Kansas, had been sent to Lansing from Shawnee County in 1933 to serve ten to twenty-one years for a Topeka bank robbery…Swain, age forty, a tall thin chain-smoker, raped and murdered a woman in Marshall County in 1925 and was serving a life sentence…Swift, age thirty-six, was a habitual criminal from Rice County, Kansas, serving a life sentence, primarily due to multiple theft and robbery convictions. Eldridge, thirty-one years of age, an Oklahoma laborer, was serving ten to fifty years for having robbed the bank in Peru, Kansas, in Chautauqua County, in 1931, which took place while he was on parole after having robbed an Oklahoma bank in 1928.*[142]

After these five convicts escaped from Lansing in 1939, "Kansas Attorney General Jay Parker gave the assignment to capture and return the five escapees to Lansing to the KBI. The small, elite, fledgling bureau was not yet two years old." The staff consisted of one director, Lou Richter; nine special agents; and one secretary. Director Richter was previously the sheriff of Marion County. All agents were required to have at least six years' experience in law enforcement. After receiving the assignment to bring the five escapees to justice, the KBI gave the task top priority.

> *Lloyd Swain, following the escape from Lansing, raped a young mother in Arkansas City and several women in Wichita before crossing the state line into Oklahoma. He was captured on August 9, 1941, near Bartlesville, Oklahoma, by Kansas Bureau of Investigation Director Lou Richter and three KBI special agents, Joe Anderson, Clarence Bulla, and Henry Neal, assisted by Oklahoma authorities…This was the first apprehension of a major fugitive by the young agency.*
>
> *Swift and Eldridge were eventually trailed by the KBI to San Diego, California. With the assistance of local law enforcement, they were quietly taken into custody by Director Richter and Special Agent Anderson on October 23, 1941, and returned to Lansing.*
>
> *Hight and Wetherick, however, were a different story.*[143]

Larry Welch served as KBI director from July 18, 1994, to June 1, 2007, and authored a book, *Beyond Cold Blood: The KBI from Ma Barker to BTK*, which was published by the University Press of Kansas in 2012. The book is an insider's view of the KBI and some of the cases it investigated. Welch's work is a valuable primary source on the pursuit and capture of Hight and Wetherick; therefore, it will be quoted here at length. The Joe mentioned is special agent Joe Anderson, who was operating undercover on the case.

> *Hight and Wetherick became so comfortable with Joe that they began to discuss openly in front of him their plans to rob a bank, maybe more than one. They told him that they were considering banks in Lamar, Colorado; Hugoton, Kansas; and Macksville, Kansas. Joe accompanied Hight and Wetherick on trips to Lamar and Hugoton to case those banks. He did not accompany them when they cased the Macksville bank. But he was still at the ranch when they returned from Kansas and announced it would be Macksville. Robbing the bank there, they told Joe, would be like taking candy from a baby.*

Both had agreed Lamar was too close to their ranch hideout, and Wetherick had preferred Hugoton. But Macksville was in Stafford County, Kansas, immediately north of Pratt County, where Hight had robbed a bank years earlier. Hight also pointed out that Stafford County, a large county with few people, only had three law enforcement officers to cover the county: a sheriff, an undersheriff, and one deputy. With any luck at all the three would be at St. John, the county seat, thirteen miles east of Macksville, when they robbed the bank and headed west.

Joe agreed with them that it all made sense, so much that he wished he could go with them. He had to return to Oklahoma, however, for a few days on a family matter. Hight told him to be sure and return to the ranch pretty quick to help them count money, because he and Frank were going to go back to Macksville within the week, and he told Joe not to worry; there would be more trips to Kansas in the future.[144]

Joe left the hideout, a deserted sheep ranch twenty miles from Lamar, and drove toward Lamar, where he telephoned Director Richter at the KBI headquarters. "Following his first visit to the ranch, Joe had confirmed Richter's worst fears. Hight and Wetherick had at least three shotguns, two rifles, two Colt .45 automatic pistols, a German Luger, and many boxes of ammunition… He also reported that Hight and Wetherick each kept a pistol at all times in their coveralls, of which they seemed to have an inexhaustible supply."[145]

Special agent Joe Anderson had learned Hight and Wetherick planned to rob the bank in Macksville, but he didn't want to push his luck and ask which bank—there were two in the small town. The KBI agents would have to work with the information they had and decided that because both banks were on the west side of the main street and they were both in the same block it might not be an issue.

Stafford County Sheriff Logan Sanford and the KBI staked out both Macksville banks for almost a week. It had been difficult maintaining concealment for seven officers in such a small town and especially difficult adequately covering both banks. Personnel at the banks had been informed. There was no other way to do it. The employees and their families had been sworn to secrecy by Director Richter and Sheriff Sanford. Others at certain businesses adjacent to the banks were also informed, reluctantly, by the lawmen. Director Richter and Sheriff Sanford were both beginning to suspect that, despite their best efforts, they had confided in too many people or had somehow tipped their hand to the would-be bank robbers.

For the first two days, officers were placed inside each bank behind newly erected false partitions. But Richter had become uncomfortable with that strategy. The officers would not be able to respond quickly from behind such obstructions. He and Sheriff Sanford each preferred to take Hight and Wetherick outside the bank, before entry, to minimize the risk of bank employees and customers. Therefore, they reduced the number of officers inside each bank to one and spread the others out within selected business establishments on both sides of the street...it was agreed that September 16 would be the last day. The stakeout would end at the close of business that day. They would then have to admit that Hight and Wetherick, for whatever reason, had changed their minds about Macksville.[146]

Clyde Barrow's letter to Henry Ford didn't comment on the color of the car he preferred; however, Hight and Wetherick must have liked blue

KBI agents Clarence Bulla (left) and Joe Anderson with the bank robbers' automobile. *Photo courtesy Margaret Sanford Symns from the Logan Sanford collection.*

because the black car they stole from the dealership in Satanta had been painted blue with a brush. The stolen Pottawatomie County, Kansas license plate had been altered to read eighty-nine from the original thirty-nine.

> *Shortly after 9:00 A.M. on September 16, a new 1941 eight-cylinder Ford, occupied by two men, drove slowly up the main street of Macksville, Kansas, a town of approximately 800 people...The car headed north up the main street, made a U-turn at the end of the block, and cruised back south before turning slowly toward the curb in front of the Macksville State Bank.*
>
> *There were seven Kansas lawmen on the scene—four KBI special agents (Joe Anderson, Clarence Bulla, Roy Dyer, and Harry Neal), Director Richter, Sheriff Sanford, and Undersheriff Wesley Wise. Some of them who saw George Raymond Hight's startled expression as he stepped from the passenger side of the Ford, later agreed that Hight had recognized Joe, or rather KBI Special Agent Joe Anderson, as one of the well-dressed men confronting him with guns drawn and demanding the pair's surrender. That might explain why Hight fired wildly when he fired the first shot. He was given no second opportunity to improve his marksmanship, however. Five of the seven officers returned his fire, killing him instantly and riddling the Ford as Wetherick attempted to drive south to Highway 50. Wetherick died within the next several seconds. The car, moving slowly, and with seven holes in the windshield in front of the lifeless Wetherick, continued down the street. Richter ran alongside the car, jumped onto the running*

The bullet-riddled 1941 Ford auto used in the Macksville, Kansas attempted bank robbery. *Photo courtesy Margaret Sanford Symns from the Logan Sanford collection.*

Dead would-be bank robbers in their car after a failed attempt to rob a bank in Macksville, Kansas. *Photo courtesy of Margaret Sanford Symns from the Logan Sanford collection.*

board, and brought the driverless car to a stop...The days following the Macksville shootout were heady times for the KBI. Praise poured into KBI headquarters from around the state and the nation. The KBI was the darling of the Kansas press and the citizens of the state.[147]

Perhaps not as dramatic as the FBI and the mob shooting it out with Tommy guns, but it was just as effective.

Today, the contest continues, as it has from the beginning—between right and wrong, between criminals and lawmen and between banks and bank robbers. The KBI and local law enforcement agencies continue to be a professional force working to bring Kansas bank robbers and other criminals to justice.

NOTES

Introduction

1. Doti and Schweikart, *Banking in the American West*, 7.
2. Todd, *Balance of Power*, 1.
3. Kuhn, *History of Nebraska Banking*, 5.
4. Doti and Schweikart, *Banking in the American West*, 10.
5. James C. Horton, "Business Then and Now," in *Transactions of the Kansas State Historical Society*, 143, 144.
6. Ibid.
7. Edge, *Cat Roads*, 16–17.

Chapter 1

8. Van Zwoll, *America's Great Gunmakers*, 72.
9. All quotes in this story are from Loy Edge, "Banker Got the Drop on Bandits," *Kansas City Times*, August 31, 1973.

Chapter 2

10. "Abominable Bum with Bomb," *Kansas Banker* 28, no. 9 (October 1938), 7.
11. Centers for Disease Control and Prevention, "Brief Report: Exposure to Tear Gas from a Theft-Deterrent Device on a Safe—Wisconsin, December 2003," http://www.cdc.gov/mmwr/preview/mmwrhtml/mm5308a4.htm.

12. Diebold, "History," http://www.diebold.com/company/overview/history.html.
13. Daniel M. Graffeo, "Lachrymatory Agents Used in Protecting Safes & Vaults," www.tmilock.com/kb/file/16/14/.
14. Centers for Disease Control and Prevention, "Brief Report."
15. "Abominable Bum with Bomb," *Kansas Banker*.
16. Svenvold, *Elmer McCurdy*, 60.
17. Ibid., 5.
18. "Sideshow Outlaw: Elmer McCurdy," http://www.usgennet.org/usa/ok/county/logan/tidbits/elmer.htm.
19 Bonnie Bailey Vaughn, "Bonnie Bailey Vaughn's Notebook" (Scott City, Kansas) *News Chronicle*, quoted in *History of Early Scott County*, 317.
20. *History of Early Scott County*, 317–18.
21. Cheyenne County Historical Society, *History of Cheyenne County, Kansas*, 48.
22. Ibid.
23. Ibid.
24. McKale and Young, *Fort Riley*, 126.
25. *Sausalito* (California) *News*, January 19, 1918, vol. 34, no. 3.
26. "The Camp Funston Catastrophe," *Kansas Banker* 7, no. 12 (January 1918), 18.
27. Bureau of Labor Statistics, Price Index Inflation Calculator, http://bls.gov/cgi-bin/cpicalc.pl.

Chapter 3

28. Samuel Taylor Coleridge, 1772–1834.
29. Confucius, 551–479 BC.
30. *Topeka* (Kansas) *Journal*, March 26, 1917.
31. Ibid.
32. Ibid.
33. Extract of letter from the manager of the Hiroshima Branch of the Teikoku Bank Limited of Hiroshima Japan, May 22, 1950, to the Mosler Safe Company, http://conelrad.blogspot.com/2010/08/unbreakable-hiroshima-and-mosler-safe.html.
34. *Kansas Banker* 41, no. 7 (August 1951), 22.
35. *Caldwell* (Kansas) *Messenger*, May 8, 1961.
36. Freeman, *Midnight and Noonday*, 222n.
37. Cyber Lodge, "Bank Robbery," http://www.cyberlodg.com/mlcity/rob.html.

38. "An Exciting Day in Dighton, June 27, 1922," *Dighton* (Kansas) *Herald*, June 26, 1991.
39. *Dighton* (Kansas) *Herald*, July 7, 1922.
40. Ibid.
41. Ibid.

Chapter 4

42. *Marysville* (Kansas) *Advocate*, February 7, 1963.
43. *Merriam-Webster's Collegiate Dictionary*, 11th ed. Yegg, yeggman: a thief, especially a burglar or safecracker.
44. *Marysville* (Kansas) *Advocate*, February 7, 1963.
45. *Topeka* (Kansas) *Journal*, July 11, 1925.
46. *Topeka* (Kansas) *Capital*, July 12, 1925.
47. *Kansas Banker* 15, no. 4 (May 1925), 18.
48. Ibid. 14, no. 10 (November 1924), 11–12.
49. *Topeka* (Kansas) *Capital*, July 9, 1962.
50. *Topeka* (Kansas) *Journal*, October 15, 1962.
51. *Commercial & Financial Chronicle* (Washington, D.C.) 106 (January–March 1918), Part I, 272.
52. *Lawrence* (Kansas) *Daily Journal-World*, January 18, 1952, 1–2.
53. Phillips, *Running with Bonnie and Clyde*, xi.
54. Ibid., 313.
55. Ibid., 314.
56. Ibid., xiv.
57. Ivan Pfalser, "The Bank Robbery of Dexter—1892," Caney Valley Historical Society, http://www.eccchistory.org/BankRobery1892.htm.
58. Bureau of Labor Statistics, Price Index Inflation Calculator.
59. Starr, *Thrilling Events*, 7.
60. Wellman, *Dynasty*, 253.
61. Starr, *Thrilling Events*, 35–36.
62. Ibid., 37–38.
63. The CPI Inflation Calculator only goes back to 1911. That is the 1911 buying power in today's dollars.
64. Newton and Newton, *Newton Boys*, 1.
65. Kirchner, *Robbing Banks*, 35.

Chapter 5

66. Goodrich, *Bloody Dawn*, 124
67. Burton J. Williams, "Quantrill's Raid on Lawrence: A Question of Complicity," *Kansas Historical Quarterly* 34 (1968), 143, 148.
68. Letter from Simpson Bros. to Hiram Hill, August 31, 1863. KSHS collection 382, box 1 of 3.
69. Smith, *Last Raid*, 10.
70. Bartholomew and Elliott, *Dalton Gang*, 41.
71. Samuelson, *Dalton Gang Story*, 27.
72. Ibid., 27, 30.
73. Ibid., 78.
74. Ibid., 79.
75. Ibid., 81.
76. Ibid., 100.
77. Elliott, *Last Raid*, 21, 22.
78. Ibid., 37.
79. Smith, *Daltons!*, 172.
80. Ibid., 208.
81. Betz, *Fleagle Gang*, 319.
82. Ibid., 5.
83. Ibid., 20.
84. Letter from John Alexander to Gary, April 25, 1979, Big Timbers Museum, Lamar, CO.
85. Betz, *Fleagle Gang*, 12.
86. Ibid., 15.
87. Ibid., 147.
88. Gormley, *Kansas Gunsmoke*, 42.
89. *Garden City* (Kansas) *Herald*, October 16, 1987.
90. WenDee LaPlant, *Positive I.D. The Fleagle Gang and the Lamar Bank Robbery of 1928*. Brochure for Finney County Museum Exhibit "Positive I.D.," Finney County Historical Museum, n.d.
91. Betz, *Fleagle Gang*, 96.
92. Kathleen Van Burskirk, comp., "Outlaw for My Neighbor: The Jake Fleagle Story," *White River Valley Historical Quarterly* 7, no. 1 (Fall 1979).
93. Ibid.
94. Ibid.
95. Betz, *Fleagle Gang*, 349.
96. Ibid., 5–6.

Chapter 6

97. *Kansas Banker* 10, no. 8 (April 1920), 18–19.
98. Ibid. 9, no. 6 (July 1919), 22.
99. Ibid. 15, no. 3 (April 1925), 17.
100. Ibid. 52, no. 3 (April 1965), 21.
101. Ibid. 16, no. 5 (June 1926), 10.
102. Ibid. 20, no. 4 (n.d.), 21.
103. "Coral A. Hickman," Find a Grave, http://www.findagrave.com/cgi-bin/fg.cgi?page=gr&GRid=41575387.
104. *Johnson Pioneer*, March 21, 1930.
105. Ibid., August 23, 1934.
106. Bisel and Martin, *Kansas Forts & Bases*, 75–77.
107. *Topeka* (Kansas) *Capital*, June 21, 1917.
108. *Elkhart* (Kansas) *Tri-State News*, Thursday, July 21, 1932.
109. *Wichita Eagle Magazine*, April 22, 1956.

Chapter 7

110. Doti and Schweikart, *Banking in the American West*, 97.
111. "Two Robberies," http://charlesmakleywas framed.com/html/two_robberies.html.
112. John T. Glynn, "Modern Knights of the Underworld," *Kansas Banker* 13, no. 12 (January 1924), 23.
113. Josh Fox, "10 Famous Depression-era Bank Robbers," August 1, 2011, http://listverse.com/2011/08/01/10-famous-depression-era-bank-robbers/.
114. Newton and Newton, *Newton Boys*, xi.
115. *Kansas Banker* 25, no. 9 (October 1935), 15.
116. Kansas General Statutes article 8, paragraph 1759, page 585.
117. *Kansas City Journal*, December 31, 1910.
118. Newton and Newton, *Newton Boys*, viii.
119. Ibid., 153–54.
120. *Pittsburg* (Kansas) *Daily Headlight*, Tuesday Evening, June 3, 1919.
121. Newton and Newton, *Newton Boys*, 154–55.
122. Ibid., xi.
123. *Pittsburg* (Kansas) *Daily Headlight*, Thursday Evening, June 5, 1919.
124. Newton and Newton, *Newton Boys*, 270.
125. *Kansas Banker* 9, no. 1 (February 1919), 16.

126. *Banker Magazine* 98 (n.d.), 48.
127. *Kansas Banker* 9, no. 1 (February 1919), 16–17.
128. Newton and Newton, *Newton Boys*, 216.
129. Betz, *Fleagle Gang*, 148.
130. Oliva, *Fort Scott*, 1, 80.
131. Edge, *Cat Roads*, 14–15.
132. Newton and Newton, *Newton Boys*, viii.
133. Edge, *Cat Roads*, 14–15.
134. Ibid., 223–24.
135. Wellman, *Dynasty*, 310–11.
136. *El Dorado* (Kansas) *Times*, "40th Anniversary Edition," December 19, 1959.
137. Wellman, *Dynasty*, 324.
138. "When Kansas' Fleagle Gang Ran Wild," *Topeka* (Kansas) *Capital-Journal Midway Magazine*, August 14, 1966.
139. Ibid.

Chapter 8

140. Welch, *Beyond Cold Blood*, xi.
141. Although this letter is widely published, it is probably a fake. See Phillips, *Running with Bonnie and Clyde*, 194.
142. Welch, *Beyond Cold Blood*, 1.
143. Ibid., 2.
144. Ibid., 4.
145. Ibid., 5.
146. Ibid.
147. Ibid., 5–7.

Bibliography

Bartholomew, Ed, and D.S. Elliott. *The Dalton Gang and the Coffeyville Raid.* Fort Davis, TX: Frontier Book Co., Publisher, 1968.

Betz, N.T. *The Fleagle Gang: Betrayed by a Fingerprint.* Bloomington, IN: Authorhouse, 2005.

Bisel, Debra Goodrich, and Michelle M. Martin. *Kansas Forts & Bases: Sentinels on the Prairie.* Charleston, SC: The History Press, 2013.

Doti, Lynne Pierson, and Larry Schweikart. *Banking in the American West: From the Gold Rush to Deregulation.* Norman: University of Oklahoma Press, 1991.

Edge, L.L. *Run the Cat Roads: A True Story of Bank Robbers in the '30's.* New York: Dembner Enterprises Corp., 1981.

Elliott, David Stewart. *Last Raid of the Daltons: A Reliable Recital of the Battle with the Bandits at Coffeyville, Kansas, October 5, 1892.* Coffeyville, KS: Coffeyville Journal Print, 1892.

Freeman, G.D. *Midnight and Noonday: or, The Incidental History of Southern Kansas and the Indian Territory, 1871–1890.* Edited by Richard L. Lane. 1890. Reprint, Norman: University of Oklahoma Press, 1984.

Goodrich, Thomas. *Bloody Dawn: The Story of the Lawrence Massacre.* Kent, OH: Kent State University Press, 1994.

Gormley, Myra Vanderpool. *Kansas Gunsmoke: A History of the Garden City Police Department.* Stephenville, TX: Jacobus Books, 2009.

History of Cheyenne County, Kansas. N.p.: Cheyenne County Historical Society, 1987.

History of Early Scott County. N.p.: Scott County Historical Society, Inc., 1977.

Bibliography

Kirchner, L.R. *Robbing Banks: An American History, 1831–1999.* 2001. Reprint, Edison, NJ: Castle Books, 2003.

Kuhn, W.E. *History of Nebraska Banking: A Centennial Retrospect.* Lincoln: University of Nebraska, 1968.

Martin, Geo. W., ed. *Transactions of the Kansas State Historical Society, 1903–1904; Together with Addresses at Annual Meeting, Miscellaneous Papers, and a Roster of Kansas for Fifty Years.* Vol. 8. Topeka, KS: Geo. A. Clark, State Printer, 1904.

McKale, William, and William D. Young. *Fort Riley: Citadel of the Frontier West.* Topeka: Kansas State Historical Society, 2003.

Newton, Willis, and Joe Newton, as told to Claude Stanush and David Middleton. *The Newton Boys: Portrait of an Outlaw Gang.* Austin, TX: State House Press, 1994.

Oliva, Leo E. *Fort Scott: Courage and Conflict on the Border.* Topeka: Kansas State Historical Society, 2008.

Phillips, John Neal. *Running with Bonnie and Clyde: The Ten Fast Years of Ralph Fults.* Norman: University of Oklahoma Press, 1996.

Samuelson, Nancy B. *The Dalton Gang Story: Lawmen to Outlaws.* Eastford, CT: Shooting Star Press, 1992.

Smith, David Stewart. *Last Raid of the Daltons: A Reliable Recital of the Battle with the Bandits at Coffeyville, Kansas, October 5, 1892.* Coffeyville, KS: Coffeyville Journal Print, 1892.

Smith, Robert Barr. *Daltons! The Raid on Coffeyville, Kansas.* Norman: University of Oklahoma Press, 1996.

Starr, Henry. *Thrilling Events: Life of Henry Starr by Himself.* College Station, TX: Creative Publishing Company, 1982.

Svenvold, Mark. *Elmer McCurdy: The Misadventures in Life and Afterlife of an American Outlaw.* London: Fourth Estate, 2003.

Todd, Tim. *The Balance of Power: The Political Fight for an Independent Central Bank, 1790–Present.* Kansas City, MO: Public Affairs Department of the Federal Reserve Bank of Kansas City, 2012.

Van Zwoll, Wayne. *America's Great Gunmakers.* South Hackensack, NJ: Stoeger Publishing Company, 1992.

Welch, Larry. *Beyond Cold Blood: The KBI from Ma Barker to BTK.* Lawrence: University Press of Kansas, 2012.

Wellman, Paul I. *A Dynasty of Western Outlaws.* New York: Doubleday & Company, Inc., 1961.

INDEX

A

Adams, Eddie 119, 120
Alderman, Sheriff Lloyd E. 80, 81, 83
Anderson, Harry 80
Anderson, Joe (KBI agent) 125, 126, 128
Arma, KS
 Arma State Bank 110, 113
Atlanta, KS
 Citizens State Bank 52

B

Badger Safe Protector 21
Bailey, Harvey 117, 118, 119
Baldwin, Lucius 75
Ball, C.M. (Condon & Co. Bank cashier) 70, 71
Barks, Carl
 Beagle Boys 90
 Donald Duck 90
Barrow, Clyde 55, 56, 58, 59, 124, 127
Billy the Kid 41
Bird City, KS
 Security State Bank 29
Bonnie and Clyde 55, 56, 59, 109
Briggs, Sheriff N.G. 58, 59
Brown, Charles 75
Brown, Henry (city marhsal) 38, 39, 40, 41, 42
Buhler, KS
 Buhler State Bank 114, 115, 116
Buick 80, 103, 104, 110, 121
Bulla, Clarence (KBI agent) 125, 128

C

Caldwell, KS 38, 39, 40, 42
Callahan, John 119
Camp Funston Army Bank 31, 33, 56
Caney, KS
 Caney Valley National Bank 61, 63
Capp, Al
 Evil Eye Fleegle 90
 Li'l Abner 90
Carpenter, C.T. (Condon & Co. Bank proprietor) 71
Chautauqua, KS 24, 124
Coffey, James 66
Coffeyville, KS 59, 60, 67, 69, 74, 75, 77, 98
 Condon & Co. Bank 69, 70
 First National Bank 69, 70, 73

Index

Collyer, KS
 First National Bank 53
Colt Manufacturing Company 16
Connelly, C.T. (Coffeyville city marshal) 75
Cook brothers 86
Cook, Walter. See Fleagle, Jake
Cowie, James 102
Cox, C.S. 73
Cubine, George 73, 75

D

Dalton, Adeline Lee (Younger) 67
Dalton, Bob 67, 68, 69, 74, 75
Dalton, Emmett 68, 69, 74, 75, 77
Dalton, Frank 67
Dalton gang 50, 59, 60, 67, 71, 74, 75, 77
 Broadwell, Dick 68, 69, 70, 74, 75
 Bryant, Charley 68
 Doolin, Bill 68
 McElhanie, William 68
 Newcomb, George 68
 Pierce, Charley 68
 Power, Bill 68, 69, 70, 74
Dalton, Grat 59, 68, 69, 70, 74, 75
Dalton, James Lewis 67
Department of Justice Central Bureau of Identification 90
Dexter, KS bank robbery 59, 60
Diebold Bahmann Safe Company 21
Diebold Safe & Lock Company 21
Dighton, KS
 First National Bank 43, 45, 46
Dillinger, John 16, 21
Docking, William 56

E

Eastham Prison Farm 58
Elkhart, KS
 First National Bank 103, 104
"Embalmed Bandit" 25

F

Federal Bureau of Investigation 54, 90, 123, 129
"fence" (market) 116, 117
Fleagle, Anna 83, 88
Fleagle, Florence 83
Fleagle, Fred 83, 84
Fleagle gang 78, 80, 81, 83, 88, 90, 117, 118
 Abshier, George 83, 85
Fleagle, Jake 81, 83, 86, 87, 120
Fleagle, Jake, Sr. 83, 84
Fleagle, Ralph 78, 81, 83, 84, 85
Fleagle, Walter 84
Fort Gibson Indian Territory 60
Fort Harker, KS 101
Fort Riley Military Reservation 31, 98
Fort Scott, KS
 Citizens National Bank 117, 118, 119
Fort Smith, AR 67
Fowler, KS bank robbery 46
Fults, Ralph 55, 56, 57, 58, 59

G

Garden City, KS 45, 47, 83, 84, 88
Garton, Reed (Elkhart vigilante) 103
Gebhart, Dr. Morrill E. 51, 52

H

Hamilton, Raymond 55, 56, 59
Harrison, AR 63
Havensville, KS
 Havensville State Bank 54
Hickman, Deputy Sheriff Coral A. 99, 100
Hight, George 124, 125, 126, 127, 128
Hollywood Wax Museum 25
Hoover, J. Edgar 89, 90, 119, 123
Horseless Horse Ranch 84
Huttig, William 56

Index

I

Isham Brothers & Mansur, hardware store 69

J

James, Frank 78, 79, 110, 118

K

Kanopolis, KS
 Exchange Bank 102
Kansas Bankers' Association (KBA) 91, 96, 98, 99, 100, 103, 123
 Kansas Banker magazine 52, 108
Kansas Bankers' Vigilante Committee 96, 97
Kansas Bureau of Investigation 54, 123, 124, 125, 126, 128, 129
Kansas Livestock Association 123
Kansas State Peace Officers' Association 123
Kansas State Penitentiary, Lansing, KS 18, 30, 52, 75, 105, 118, 119, 124, 125
Kelly, KS
 Kelly State Bank 36, 37, 64
Kesinger, Everett A. 80, 81
Kloehr, John 74

L

Labette County State Bank 18
Laff in the Dark 25, 26
Lamar, CO
 First National Bank 78, 79, 84, 88, 90, 125
Lawrence, KS 12, 55, 56, 58, 59, 65
Liberty Bonds 110, 112, 114, 116
Linville, Willard C. (Atchison chief of police) 15, 16, 17
Lundgren, Eskel 80

M

Macksville, KS bank robbery 125, 126, 127, 128, 129

Majors, Ollie 104
Majors, Ray 102, 103, 104, 105, 119, 120
Manter, KS
 Manter State Bank 99, 100, 101
Martin, Thomas "Blackie" 43, 45, 46, 47
McCarty, A.H. 18, 19
McCarty, Colene 18, 19
McCarty, Isaac (Ike) 18, 19
McCurdy, Elmer 23, 24, 25, 26
McKee, Anthony 96
Medicine Lodge, KS 10, 39, 40, 42
Mississippi State Penitentiary 58, 59
Mosler Safe Company 37
Museum of Crime 25

N

National Guard
 Colorado 81
 Mississippi 58
Neal, Henry (KBI agent) 125, 128
Newton brothers 109, 110, 112, 113
 Jess 110, 112
 Joe 110, 112
 Willie (Doc) 110, 112
 Willis 109, 110, 112, 113, 116
nitroglycerin (nitro) 23, 24, 35, 36, 46, 50

O

Ocean Accident and Guarantee Corporation 91, 100
Ottawa, KS bank robbery 120, 121
Overbrook, KS
 First National Bank 35, 37, 64

P

Parker, Jay (Kansas attorney general) 125
Parker, Judge Isaac C. 61, 67
Parrish, Amos "Newt" 78, 79, 80
Parsons, KS
 First National Bank 21, 22
Pendergast, Tom 116
Phillips, John Neal 55, 56, 58

INDEX

Q
Quantrill, William 55, 65

R
Ragel, Bill
 Ragel's Monument Service 47
Richardson, Lee (Garden City chief of police) 45
Richter, Lou 125, 126, 127, 128
Ridgedale, MO 86
Roosevelt, President Teddy 61
Royston, Howard "Heavy" 80, 81, 85

S
Samuelson, Nancy B. 67
Sanford, Logan (Stafford County sheriff and second KBI director) 9, 126, 127, 128
Schermerhorn, Will D. 94, 95
Scott City, KS bank 27, 56, 84
self-hanging gallows 85
Sharps rifle 93
Six Million Dollar Man 25
Smith, Robert Barr 77
Smith, William 40, 41
Starr, Belle 60, 96
Starr, George 60
Starr, Henry 60, 63, 64, 96, 118
Starr, Tom 60
St. Francis, KS
 First National Bank 30
St. Marys, KS bank robbery 51
Studebaker Commander 80
Stutz Bearcat 63
Sullivan, Sheriff Jim 49, 50
Summit View Cemetery 27
Sutton, Willie 109
Sylvan Grove, KS bank robbery 94

T
Teikoku Bank, Hiroshima, Japan
 atomic bomb 37
Thompson, John T. 16

Thompson submachine gun 15, 16, 17, 93
Tyro, KS
 Tyro State Bank 113

V
Valley Center, KS bank robbery 51
Victory Bonds 110, 112
vigilantes
 deputy sheriffs 96
 First Annual State Shoot 97
 "minute men" 99

W
Waterville, KS
 Citizens State Bank 49, 50, 63, 64
 State Bank of Waterville 49, 50, 63, 64
Welch, Don (Elkhart vigilante) 103
Welch, Larry (KBI director) 125
Wesley, John 40, 41
Wetherick, Frank 124, 125, 126, 127, 128
Wheeler, Ben (deputy marshal) 38, 40, 41
Wheeler, KS
 Farmer's State Bank 29
Whisler, Captain Lewis R. 32, 33
Whitewater, KS
 Peoples State Bank 52
Wineinger, Dr. William 81
Winona, KS bank robbery 46
Wornall, Kearny 32

About the Author

Eldon Clark Photography.

Kansas native Rod Beemer is an independent writer, historian and speaker whose published works include twelve nonfiction books, an e-book novel and numerous magazine and newspaper articles, as well as anthologies. He is on the editorial review board of *Greasy Grass*, the journal of the Custer Battlefield Historical & Museum Association, and is a member of the Kansas State Historical Society, West Texas Historical Association, Smoky Hill Trail Association, Westerners International and Fort Larned Old Guard. Rod lives in Minneapolis, Kansas, with his wife of forty-seven years.

Visit us at
www.historypress.net

This title is also available as an e-book